HOW TO DRAW
MANGA CHARACTERS

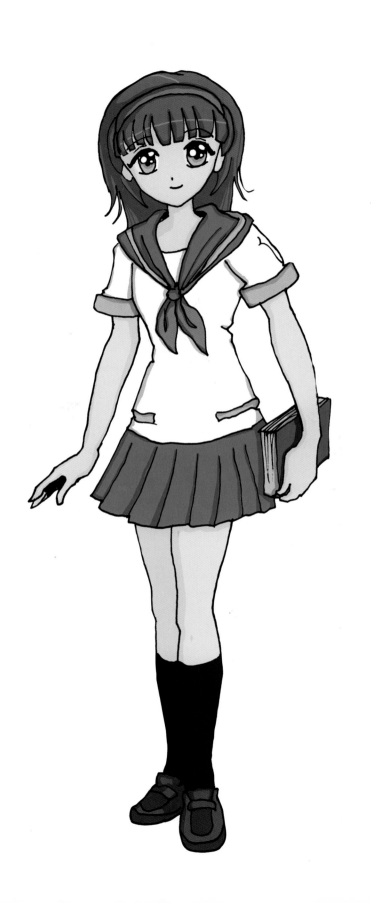
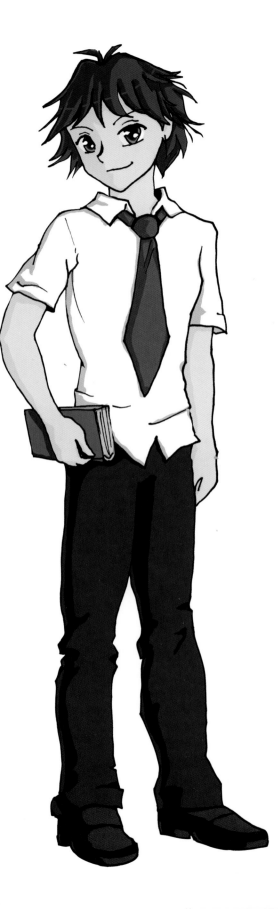

HOW TO DRAW
MANGA CHARACTERS

A BEGINNER'S GUIDE

J.C. AMBERLYN

MONACELLI STUDIO

Published in the United States by MONACELLI STUDIO,
an imprint of THE MONACELLI PRESS

Library of Congress Cataloging-in-Publication Data

Names: Amberlyn, J. C., author.
Title: How to draw manga characters : a beginner's guide / J.C. Amberlyn.
Description: First American edition. | New York : The Monacelli Press, 2016.
Identifiers: LCCN 2015037165 | ISBN 9781580934534 (paperback)
Subjects: LCSH: Comic books, strips, etc.--Japan--Technique. | Figure
 drawing--Technique. | BISAC: ART / Techniques / Cartooning. | ART /
 Techniques / Drawing. | ART / Techniques / General.
Classification: LCC NC1764.5.J3 A435 2016 | DDC 741.0952--dc 3
LC record available at http://lccn.loc.gov/2015037165

ISBN 978-1-58093-453-4

Printed in China

DESIGN BY JENNIFER K. BEAL DAVIS
COVER DESIGN BY JENNIFER K. BEAL DAVIS
COVER ILLUSTRATIONS BY J.C. AMBERLYN

10 9 8 7 6 5 4 3 2

First Edition

MONACELLI STUDIO
THE MONACELLI PRESS
236 West 27th Street
New York, New York 10001

www.monacellipress.com

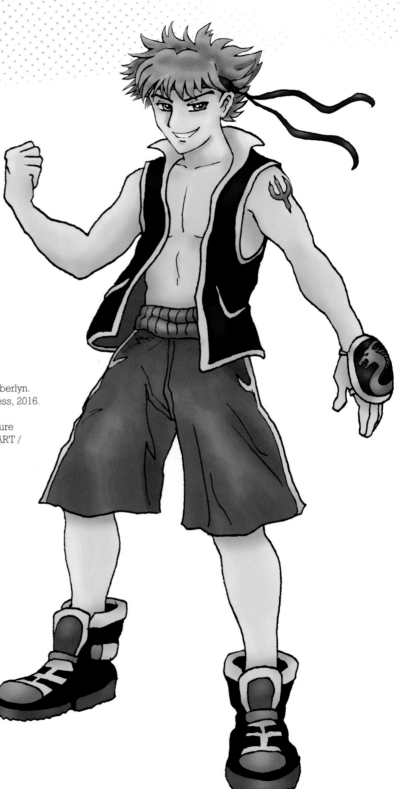

DEDICATION

I'd like to dedicate this book to my mom and Den, who have always been there for me and helped me reach for the stars.

ACKNOWLEDGMENTS

Heartfelt thanks to my family and friends. You are appreciated more than you may ever know. Ashanti Ghania helped introduce me to anime and many other fantastical things years ago. Rusty Callaway, you have been both a big help and a good friend. I'd like to thank the teachers who encouraged me on my artistic path and the editors who worked with me to help me achieve my dreams, including Victoria Craven. Laurine, you are missed. Finally, a big thank you to the people who have brought manga, anime, and animated stories to life and inspired me with their passion for the rich and varied world of the imagination and all the characters who reside within.

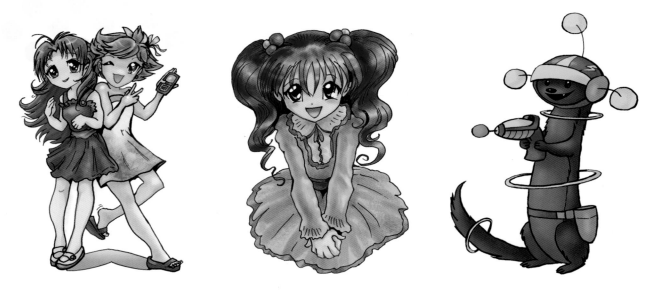

CONTENTS

INTRODUCTION

WHAT IS A CHARACTER?

What is a character? In a story, it is an individual who interacts with other characters or the environment to move the plot along, while being defined by distinctive mental and physical traits. The first thing one notices about a character is his or her physical appearance, which in most cases provides clues to the personality as well. The way he carries himself, the clothes or accessories she wears, even the way the physical features of his body are exaggerated all hint at who the character is inside. Character design determines what these individuals look like and makes them interesting, distinctive, and appealing, and manga is no exception. A well designed

A typical gothic girl character, dressed in a Victorian-inspired style.

character stands out from the crowd and may surprise with something unexpected that makes viewers want to see more, or may simply be so appealing or "cool" that viewers feel an instant connection. Either way, successful manga characters capture a viewer's interest.

There have been stories since the dawn of humankind and characters have always been part of those stories. Certain archetypes (symbolic characters or motifs) recur with such regularity that they are recognizable to most people regardless of their nationality or culture. The brave hero/heroine on a quest to save a loved one or the villain who was shunned and now seeks revenge are examples of those archetypes. There are also specific types of characters that are found in certain cultures more often than in others, and characters who are fairly unique to one culture. This book focuses on the character types found in Japanese culture and seen frequently in anime (Japanese cartoons) and manga (Japanese comics). It includes a mix of characters found throughout a great deal of cultures and stories (like the young hero taking on a quest) and characters more specific to manga (like magical girls).

CREATING A MANGA CHARACTER

When creating a manga character, it is important to decide what kind of story you are telling. Is it a fantasy set in a medieval world? A gritty and dark tale set in a gothic or horror setting? A silly school romance? The world the characters inhabit will set the tone for the characters themselves. A knowledge of the various types of stories and the characters that inhabit them is a good first step before embarking on creating your own specific world. You can choose to follow these archetypes closely. Most manga stories do. Silly school romances are usually populated by zany, funny, and mostly innocent characters. However, every now and then stories—and

characters—surprise the audience. An unexpected character in an unusual setting can provide interest or tension in the story and sometimes leads to a very memorable character. Take a silly school kid and place him in a medieval fantasy world or somehow foiling the monsters of a horror tale and you begin to have something that may have new and fresh possibilities.

Motivation is also an important factor in understanding your characters and why they do what they do—their wants, needs, jobs, schools, families, friends, and pasts all influence who they are and how they look. Different characters, born poor, who suddenly gain wealth will react to that in different ways. One revels in his new status, wearing expensive things and engaging in conspicuous consumption, showing the world that things have changed and he has this new lifestyle now. Another dresses head to toe in flashy clothes and wears all the latest gadgets. Another guy, always on the lonely side, changes his lifestyle to "belong," while another girl, fascinated by fashion and trends, hops from one new thing to another. He may feel entitled to it all and rub it in other people's faces, but for her, this bounty after years of struggle makes her so grateful that she shares it with others and spreads the wealth. Maybe he lives a philanthropic but humble life, wearing the simplest clothes, so people think that he's still poor, and then are surprised when they discover the truth. Each character is in a similar scenario, but individual personality and motivation cause each character to react in a different way and to look distinct, individual. Once you grasp a character's motivations you will have a better understanding of the direction their design needs to go.

THIS BOOK

This book is divided into several sections. The first part examines some of the most common archetypes (character types) found in manga stories, including both

humans and animals. Subsequent chapters look at some of the design elements and drawing instructions that can help you create manga characters of your own. Finally, we'll explore some ways to bring this all together into character sheets and environments, as well as personal examples of my own character creation process. This book is meant to have something for readers of many different skill levels, whether beginner or more advanced. The art instruction was largely done traditionally with pencil and pen on paper but is easily translated to digital work. The concepts apply to all character designs, however they are created.

MATERIALS AND SUPPLIES

You can use a variety of mediums to draw manga characters, from traditional mediums like paper and pencil and/or pen, to digitally generated.

TRADITIONAL MEDIUMS: PAPER, PENCILS, PENS

Look for acid-free papers that will not yellow with age; they range from drawing paper and sketchbooks to heavyweight Bristol board, which can easily withstand color markers and heavy erasing.

There are a great variety of artist's pencils. Standard pencils are often marked in order of lead hardness from 9H (very hard / light lines) to 9B (very soft / dark and black lines). HB grade pencils are right in the middle. Many artists use an HB or a 2B pencil. I often use a mechanical pencil with HB or 2B lead.

Pens also come in a wide variety of brands and sizes. I prefer a larger sized pen nib like a .05 or .08 to ink in the larger, broader lines and then go in with a smaller pen nib size like a .01 or .03 for finer details. There are also brush pens that give varying line widths for a more artsy and undulating line.

Some of the pens I used for the illustrations in this book include Pigma Micron pens, Pigma Sensei pens, and Faber Castell PITT artist pens. Look for artist's pens with acid-free ink. Just as paper can yellow with age if it's not acid-free, so too can ink strokes. If you are using pencils without pens, consider coating your finished drawing with an artist's fixative spray in order to prevent accidental smudging.

DIGITAL MEDIUMS

Digital mediums require a much more expensive initial investment but lower recurring costs. The most basic investment is some sort of computer and a graphic arts program such as Adobe Photoshop.

A high-quality graphics card helps create the best-quality images and highest speed. Look into drawing tablets, which allow you to draw on the computer with what is basically a pen instead of a mouse, which can be difficult for many people. I used a drawing tablet for digital illustrations and coloring for this book. When working in digital files, try to keep your images at a high resolution so that they look good in print. A size of 300 dpi (dots per inch) or higher is usually a good number. Web images are often 72 dpi. You can lower the dpi count for web later but trying to take a low-quality image and make it higher quality generally does not work well.

There are numerous free online art programs you can download. A search of "best free art software" will pull up numerous possibilities. (Warning: If you are a minor, be sure to get an adult's help before downloading and installing anything off the Internet.)

This character loves animals and nature.

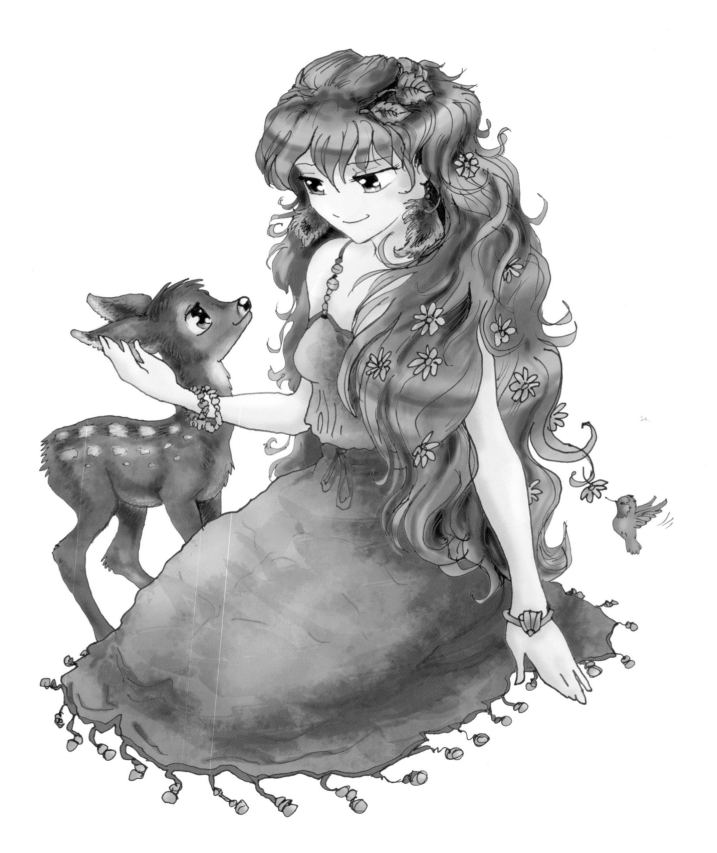

1 CHARACTER TYPES

This chapter provides an overview of some of the more common character archetypes, themes, colors, and the associated symbology (the use of symbols) that can help you understand them. It isn't all-inclusive and is meant as a launching point for you to begin exploring the world of manga and the kinds of characters found within.

This hero is ready for adventure with his trusty dragon sidekick at his side.

MANGA CHARACTER ARCHETYPES AND STORY GENRES

Manga is populated by many different characters. While there are quite a variety of them out there, some character types make repeated appearances. These familiar personalities may wear different faces, but share enough similarities from one story to the next to be recognizable archetypes. The plucky young hero with colorful clothes and the battle-hardened warrior with a sword are just two examples of many. When creating your own characters, you don't always have to follow these archetypes but having a basic knowledge of them can be very useful. If you want a character to be easily identified by your audience, fashioning them after an archetype can create immediate recognition and emotional connection.

In addition, there are several kinds of stories that are both distinct and common enough to be instantly recognizable. For instance, if you see cute girls wielding magic wands, cards, or staffs and casting powerful spells to save the world, you know you're probably looking at a magical girl story. These specific kinds of stories, or story genres, can stand alone or more than one genre can be blended together. Many character archetypes can be found throughout most of these genres, but sometimes certain characters occur most frequently in some kinds of stories but not others.

ARCHETYPES are recurring stereotypes, or kinds of characters, that are often instantly recognizable because of their attitudes, looks, or associated symbology.

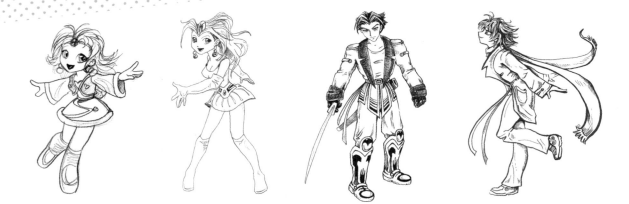

SHOJO AND SHOUNEN MANGA

There are two basic manga categories you should know: shojo and shounen. In a nutshell, shojo is manga for girls and shounen is manga for boys. However, these definitions can vary from writer to writer and story to story. In fact sometimes shojo manga has shounen elements and vice versa. The characters and themes listed later in this chapter can be found in both shojo and shounen manga. These are general categories and both boys and girls may like either kind of manga.

Shojo (Girls' Manga)

Shojo is often manga geared toward girl readers and viewers, 10 to 18 years old. But that's a broad category, and it includes many different kinds of stories, from a normal, slice-of-life tale to action and adventure. But in general, shojo is recognized as a manga story that usually features a girl protagonist (heroine) and often includes romantic elements and well-developed relationships between characters. A related manga category to know about is *josei manga*, which is manga aimed at women.

Shounen (Boys' Manga)

Shounen is the boy's counterpart to shojo. Shounen usually features a male protagonist (though not always) and tends to be more action-oriented than shojo. There may be fighting, monsters, and competition to prove who the best is and find one's place in society. The adult version of shounen is *seinen manga*, which is geared toward men. Shounen manga may be drawn in a more realistic, less "cute" style, though this isn't always the case.

SOME COMMON MANGA CHARACTER TYPES

There are quite a few character types that recur throughout various anime and manga stories and we'll go over those types in this chapter. Virtually every story has a hero or heroine as the main character/protagonist, and these characters can range from dynamic, athletic, and take-charge to sweet, innocent, and vulnerable, from seemingly ordinary to magical and mystical. The character's features, expressions, posture, wardrobe, accessories, and hair color and style all contribute to communicating a character's essence, and can be used to highlight a character's transformation as well.

YOUNG HERO/HEROINE

Many (though not all) stories feature a young hero or heroine as the main character/protagonist embarking on the classic "Hero's Journey," a storytelling tradition outlined by American scholar Joseph Campbell. In this, the protagonist is called to undertake a journey into the unfamiliar in order to solve a major problem. Along the way, he or she meets other individuals who help in the quest, and faces difficulties that must be met head-on and successfully solved. In the end, the hero returns to his home, town, or loved ones having been transformed by this personal journey into a wiser, stronger person. She usually returns as the victor, having found either what she was looking for or something else equally important.

The hero or heroine usually stands out physically in some way, whether it's because of their spiky or otherwise attention-grabbing hairstyle or their equally eye-catching clothes. Their personality is often loud, positive,

This hero character stands out in every way, from confident body language to his spiky hairstyle and colorful clothes.

and energetic and they usually have colors that match: bright yellows, reds, or other hues that help them stand out in a crowd. (Though there are some exceptions.) Just keep in mind that you will be drawing this character a lot. So keep the details and characteristics simple enough that you don't get tired of drawing the same thing over and over again.

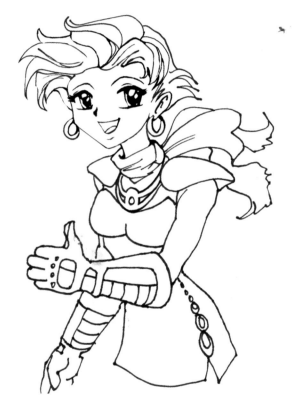

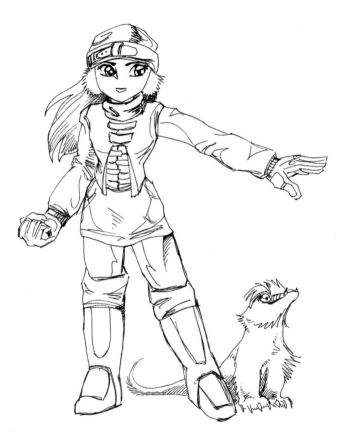

This girl reflects the cheerful, can-do attitude these young heroes or heroines usually possess.

The warm, bulky clothes that this girl wears indicate she is from a cold climate. She is accompanied by an animal companion that looks something like an ice dragon, further hinting at the cold weather they must both typically endure. Many heroes and heroines have some sort of animal or creature companion.

WARRIOR

The warrior is a male or female character who knows how to kick butt, whether it's with swords, guns, or simply their fists. In manga she may be a samurai, ninja, or other person skilled in martial arts. It can be helpful to study martial arts to gain an understanding of how practitioners move, dress, and live. Warriors may be big, muscular brutes (sometimes gentle giants who only resort to violence when absolutely necessary to protect the innocent); they might be thin, quick, and acrobatic; or they might be something in between.

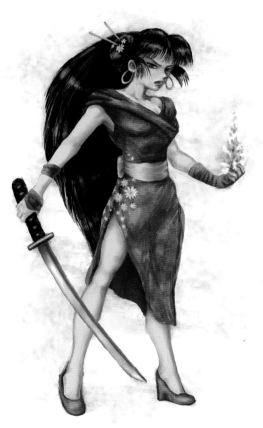

This swordswoman adds a touch of elegance to her tough, warrior persona with her dress and hair and a touch of magic with the flame in her hand.

Drawn in the more realistic style of some shounen mangas, this swordsman wears a utility belt and armor, a straight-forward representation of his persona.

MAGICAL GIRLS

Magical Girls are a classic anime staple and provide a very distinctive and appealing look that is instantly recognizable. These heroines wear colorful and often elaborate costumes. Their outfits are usually feminine or cute, and may feature adorable or oversized accessories. They often display a fantasy element dashed with a touch of whimsy and cheer. And magical girls usually are cheerful, especially the main characters. The typical story involves girl students by day who possess magical powers that transform them into special "magical girls" when danger appears or there are people to save. Sometimes magical girls show up in a fantasy setting where they are always in this "heroine" mode. These heroines often wear oversized elements in their clothing and/or accessories on their heads, and they usually carry some sort of magical item. This magical item is rarely ever a weapon; more often it's some kind of staff, card, wand, gem, or other article that gives the girl power.

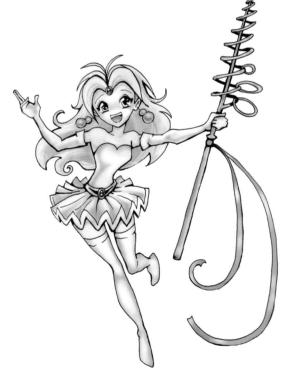

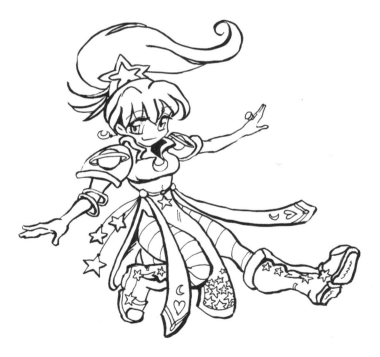

Lyra is a character of mine who embodies a typical magical girl: she's cheerful, energetic, feminine, and kind. She holds a magical staff and wears light, pastel-colored clothes. Note the gems on her forehead and belt that further mark her as magical.

This magical girl was designed with the night sky in mind. Her most recurrent motif is a star, accompanied by the occasional moon, planet, or heart. Using a star and galaxy motif over and over again helps coordinate her outfit and make everything seem unified. One would expect she has some magical power related to the stars or cosmos.

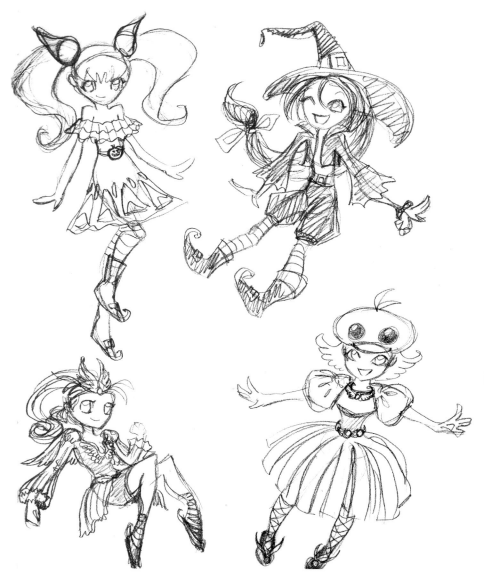

This magical girl's dress features a more complicated design and pattern, complete with little bells.

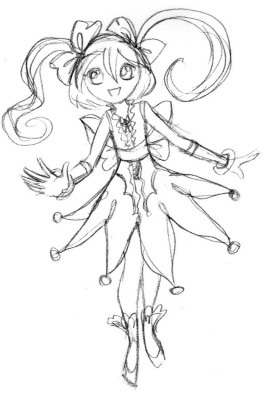

In these sketches of several magical girls, the top two have a sort of Halloween theme going, complete with candy corn designs (left) and witch's hat (right). In the bottom two sketches, I was thinking more of birds—wings, feathers, and bird-shaped hats all contribute to that theme.

SCHOOL KIDS

Anime and manga is full of school! In Japan, students usually wear uniforms modeled after European sailor uniforms. Each school's uniform is a little different and features different colors. But typically the boys' uniform consists of a shirt, tie, jacket, and pants, while the girls' outfit typically consists of a shirt, jacket, and skirt. There are also summer and winter uniforms as well as gym outfits. Uniforms may include some sort of school badge as well.

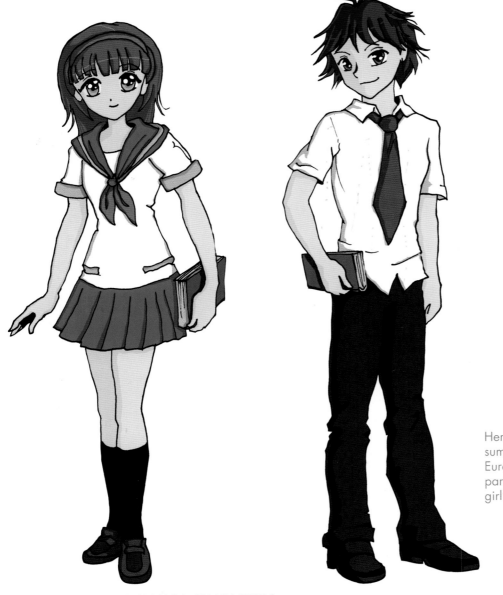

Here are a girl and boy in summer school uniforms. The European sailor influence is particularly evident in the girl's uniform.

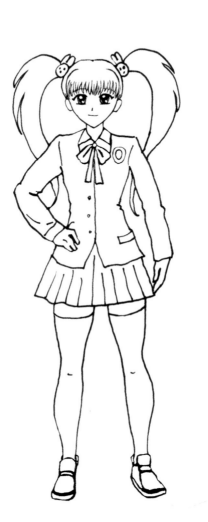

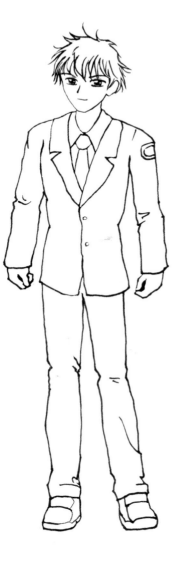

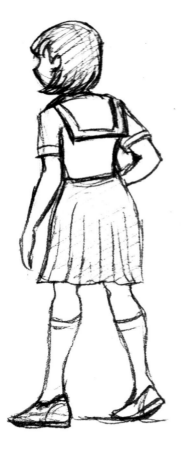

A girl and boy in winter uniforms, including jackets with school badges.

Here's a look at the back of a girl's summer school uniform.

MOE CHARACTERS

In general, moe characters evoke a sense of emotional attachment. Viewers look at moe characters and want to care for and protect them. They are usually young and innocent and may be clumsy or helpless. A moe often has large eyes and an open, guileless demeanor. In addition to a type of character, moe can be the story itself, a story populated with many moe people. Though they are most often girls, moe characters can sometimes be young boys.

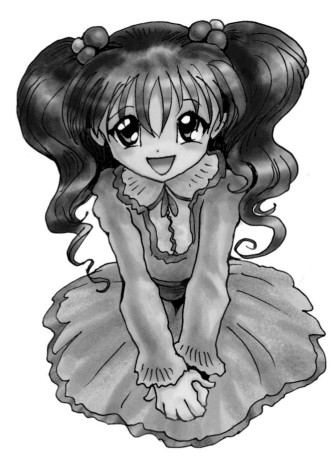

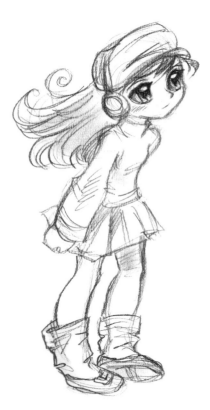

This young girl is cheerful and innocent. She is drawn looking slightly up at the viewer, which makes her appear more vulnerable. The way her hands are clasped together makes her look a bit shy and awkward.

A number of things about this girl suggest innocence, from her large, soulful eyes and wistful expression to the way she shuffles her feet.

CATGIRLS/CATBOYS

Catgirls are a popular staple of anime. Known also as "neko" (cats) or "nekomimi" (cat ears), they typically feature an anthropomorphic cat with a combination of human and feline features, or what appears to be a human girl wearing cat ears and tail. There are catboys as well, but they are less common. Sometimes manga stories feature human-like characters with other animal traits, such as those of dogs or foxes (kitsunes).

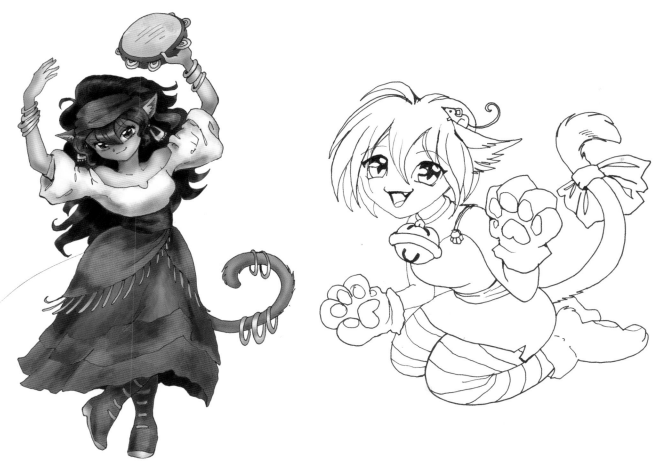

Some of the fun of character design is combining different characteristics into one character. In this case, I combined two character concepts: a catgirl and a gypsy. This catgirl is hence wearing a flowing, layered outfit with scarves and lots of jewelry.

Some catgirls have exaggerated feline features that are either an actual part of their anatomy or items of clothing like oversized gloves and boots that look like paws. This whimsical, cute catgirl wears a collar with a huge bell on it and a bow tie on her tail, both very feline.

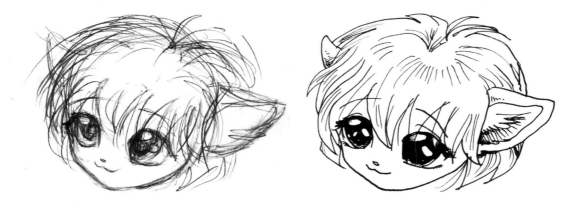

This catgirl looks like a kitten. She has huge, soft eyes, a large forehead, and tiny nose and mouth, which make her seem young and innocent. The pencil sketch on left can be seen in the inked and final version on the right.

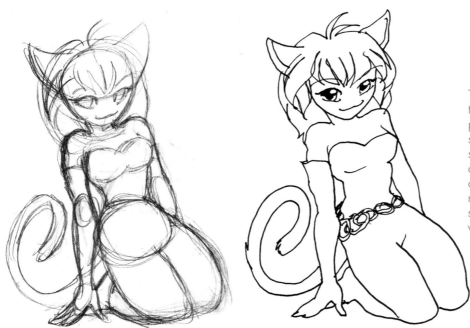

This earthy catgirl wears something a little more formfitting, plus a mischievous smile. The smile is emphasized with a subtle cat-like grin, or "w" shape of the mouth. The pencil sketch on the left reveals the underlying roundness of the character as shown in the inked and final version on the right.

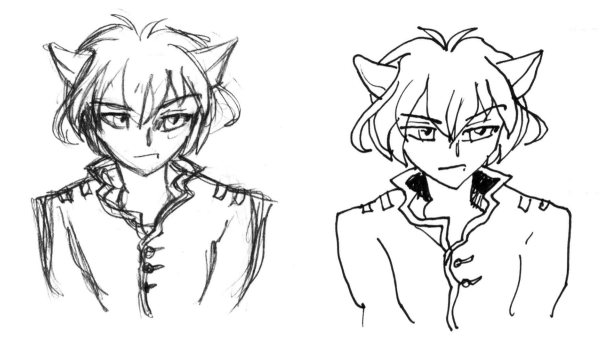

Catboys are less common than catgirls but they do exist. Sometimes they are depicted as rather aloof, like this fellow. Notice his flat, unimpressed expression, which is emphasized with flat lines and heavily lidded eyes. His eyebrow is arched, indicating he's probably a skeptical or slightly suspicious character. The pencil sketch at left needed only minor tweaks to be inked and finalized, at right.

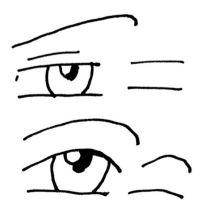

The eye on the top is the eye used in the drawing of the catboy above. Note the flat lines and arched eyebrow. The eye on the bottom is an example of a friendlier or livelier eye. Note the rounder shapes—a relaxed eyebrow and a perkier shape to the eyelids. If I had used the friendlier eye expression, it would have totally changed the catboy's entire character feel.

GOTHIC CHARACTERS

Gothic refers to a type of manga that is often darker than most other genres, sometimes featuring characters like vampires or witches. It may contain a horror element. Clothing is often elaborate and looks like it is from the Victorian era (or at least inspired by it). For women think long dresses, many layers of ribbons and lace, corsets, fitted jackets, laced boots, and frills. Men are often dressed in long jackets, tuxedos, or other fine or formal clothing. Gothic colors tend to be dark and include a lot of black. Look up the Victorian era and clothing while researching ideas for gothic characters. Another common gothic character trait is a certain somber expression. Gothic characters commonly appear rather expressionless or subdued.

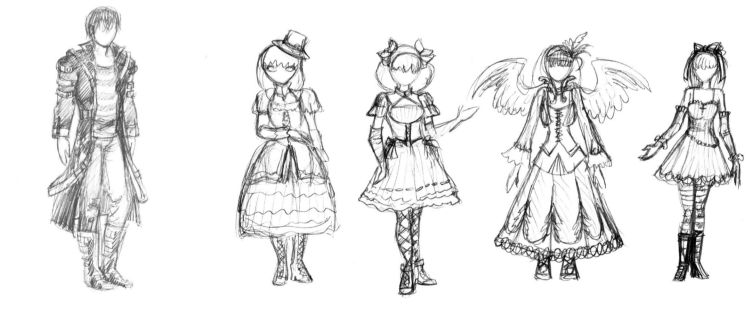

Gothic males often have very elaborate outfits, from a very classic, sophisticated style to one with numerous buckles, straps, and other accessories on heavy coats. They might wear boots and some Victorian lace and frills as well.

Here are several concept sketches I made to find a gothic character I wanted to develop. I eventually chose the one second from the left. (See opposite for the finished version.) Most goth girls feature some kind of Victorian sensibility—trim waists, frills, lace, bows, and heavy fabric. The girl at left has a small, jaunty hat, another Victorian detail. Sometimes gothic characters also have wings, like on the third version. These wings can be large, or small and stylized. There are many different takes on a gothic look but most appear a little old-fashioned somehow.

This girl has a slightly Victorian vibe, with lots of ribbons, lace, and frills, and she's ready for a cup of tea. Her small, thin-line mouth renders her poker-faced and restrained.

CHIBIS

Chibis are an iconic manga character. Their appearance in a story is less about genre and more about the *way* they are drawn. Chibis have a distinctive super-deformed style: huge head and eyes on a tiny, very simplified body. They can appear throughout many different manga stories but are most common in funny, lighthearted, or magical mangas. Sometimes chibis maintain the same look at all times. Quite often, though, they are regular characters suddenly drawn in a chibi style for an extra dash of cuteness or silliness. This is especially true with human characters. Once they've reacted to something in chibi form, they return to normal. At least until the next time they have an especially cute or silly reaction to some event or person.

You can take the same basic underlying form (top) and add different ears, eyes, nose, and tail to make different chibi animals such as a koala (lower left) or cat (right).

This koala bear has a huge head and small body. Big, fluffy ears add to its cuteness.

This little chibi girl has tiny hands and very simple legs and feet, all of which contribute to her cuteness quotient.

MASCOTS

Manga mascots are similar to chibis. They are cute and rather simple. However, their appearance usually remains constant (though some mascots can change into a more powerful, fiercer-looking form when needed). A mascot is often an animal or anthropomorphic object that exists mostly as a cute supporting character to the humans of the cast.

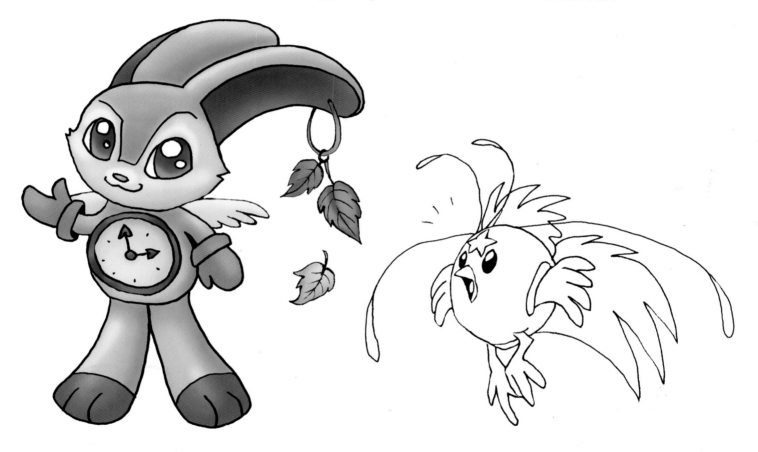

This whimsical creature isn't any particular animal, though it has vaguely rabbit-like qualities. It also features elements like a watch and changing leaves that suggest time and the changing of the seasons. This might work well in a story that involves time travel or manipulation or perhaps takes place over a lengthy period of time.

Here is my own mascot character Space Chicken. He is Lyra's loyal companion. Note his simplified, almost egg-like shape. He's cute but he's not necessarily chibi: he doesn't have a separate, large head. Instead, head and body are meshed together in one simple shape, making him more of a mascot. He's also quite fanciful—chicken-like, but definitely a fantasy-based chicken.

FANTASY CHARACTERS

Manga is populated with fantasy creatures like those found in other stories around the world, including dragons and unicorns. There are also other creatures more unique to Japanese or Asian culture, such as kirins (see opposite) and tengus (birdmen of Japanese folklore). In manga, these creatures are often drawn with flowing manes, whiskers, or other elaborate features.

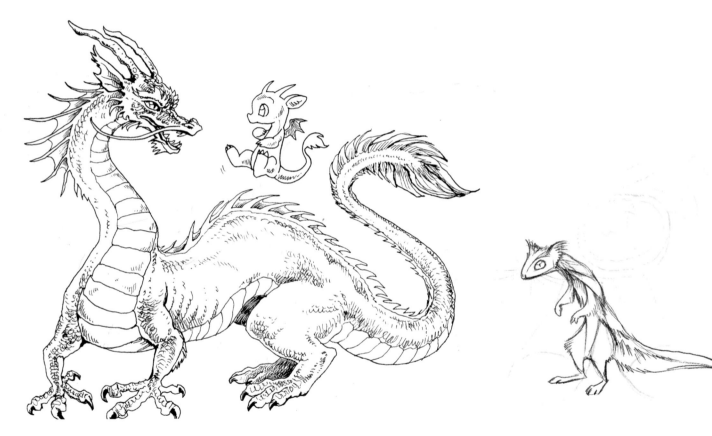

Here are two dragons, drawn in very different styles. The larger, much more detailed and realistic-looking dragon looks back at a quite simplified chibi dragon. More realistic-looking Asian dragons usually feature whiskers and almost fur-like areas on their chins, necks, elbows, or the top of their spine. Those physical features are softened and simplified in the chibi dragon.

This fantasy creature isn't any species in particular, though it is certainly reminiscent of a weasel. But it's not exactly like any specific animal found on Earth.

This winged unicorn, or alicorn, might dwell in a fantasy world with magical girls or other whimsical characters.

This is a kirin. Kirins are like unicorns with either one or two multi-branched horns. They have scales as well as fur, a mane, and hooved feet. They vary in appearance, sometimes looking more deer-like and other times looking more lion-like. Kirins look fierce but are generally wise and gentle.

SOME COMMON TERMS AND COLOR ASSOCIATIONS

Here is a list of some common Japanese terms one can find in anime and manga that describe specific character types found throughout a wide range of stories or genres. For instance, one could easily find a genki, tsundere, dandere, or any of these other characters in, say, a magical girl story.

CHARACTER PERSONALITY QUALITIES

Here is a list of the most commonly appearing personality/character traits in anime and manga storytelling.

- **Genki:** Genki is a Japanese word that often means "energetic," and genki characters definitely display these qualities. Most often (but not always) a girl, they are full of enthusiasm and energy. Bouncing around and running everywhere, they can make the people around them feel exhausted just by watching them. They tend to act quickly and shout in loud outbursts at times. The genki character is usually quite confident (or at least acts that way) and may even be somewhat bossy.

- **Tsundere:** This character acts aloof or irritated on the outside, but is secretly rather kindhearted. Tsundere flip between these two extremes, especially when faced with a person they like. They are afraid of being vulnerable, so they hide behind a mask. If they do something nice for the person they like, they will try to hide their true feelings by insisting, "it's not because I like you or anything!"

- **Kuudere:** Like the tsundere, this character can act cold and aloof, but tends to be less blatant about it. This is a more subtle form of holding back emotions. Kuu-

These two girls feature characteristics common to the "dandere" and "genki" character types. The girl on the left has blue hair and seems a little bit shy. She might be a moe or dandere personality type. The girl on the right has reddish hair and seems much more outgoing and genki.

dere appear calm, collected, and possibly apathetic, and it takes a lot to get to know the real them. But if someone gains their trust, they can let their guard down, showing the sweeter, kinder person they are inside.

- **Yandere:** A typical yandere is someone who seems nice on the outside but is secretly so obsessed about their love interests that they can turn violent or controlling.

- **Dandere:** This character acts almost emotionless on the outside and is usually very shy. Getting a dandere to reveal his or her true self requires the work of just the right person. When that individual comes along, the dandere will eventually open up, revealing a nice person behind the emotional walls.

HAIR COLORS

There are no absolute rules regarding how the color of a character's hair indicates what their personality is like, but there are certain archetypes that pop up frequently enough that it can be good to be aware of them. Sometimes creators will deliberately choose one hair color to set up an expectation of what that character will be like, only to surprise the audience later on in the story as the character's true nature is revealed.

- **White**: Not a neutral color in manga and anime, white can be old and/or powerful and is often sophisticated, mysterious, or magical. White-haired characters are often, but not always, quiet or subdued in nature; they may be cold or distant.

- **Blond/Yellow**: Blondes can be the stereotypical "airhead," a conniving and manipulative character, or their hair may suggest a "foreign" quality. Blondes can

also be characters who (perhaps unwittingly) attract chaos. They tend to have an energy and vitality to them.

- **Green**: Green hair often indicates a quieter, possibly more introspective character—smart, caring, muted. However, green can also be the color of jealousy, and sometimes characters with green hair are full of envy.
- **Red/Orange**: Like the stereotypical redhead, this character is usually fiery, passionate, and loud. Red/orangeheads are impulsive and hotheaded. Occasionally, red can also mean a supernatural or enchanted character.
- **Pink**: Pink hair is often feminine and tends to represent an innocent, bubbly, kind personality.
- **Blue**: Blue hair usually signifies a cold, calm, or focused person. They may be introverted and/or wise.
- **Purple**: The color of royalty, purple hair may indicate an aloof, powerful, rich, or egotistical character.
- **Brown**: Brown-haired characters are often the average, ordinary, everyday characters. However, even "everyday" people can have hidden strengths, and these characters are often quite competent.
- **Black**: Most people in Japan have black hair, so this tends to be the most normal-seeming hair color and it usually means traditional, serious, and/or powerful. However, black can also bring to mind shadows and mystery.

2 DRAWING THE HEAD AND FACE

There are many ways for a character to engage a viewer's interest, but one of the most classic and compelling will always be through the face. The eyes are the window of the soul and something that the human brain is wired to notice and respond to. The large, expressive eyes of many manga characters draw viewers in and create a connection. Facial expressions hint at what the character is thinking and suggest something about his or her disposition and current state of being. The design of a character's face and head can also give the viewer clues about their personality and motivations.

The face and eyes capture a viewer's interest immediately.

HUMAN HEADS AND FACES

The comparative size of the eyes and their placement on the face in relation to the silhouette of the head provide several important clues to a character's age and personality. Young and innocent characters have very large eyes in comparison to the rest of the face. They also tend to have eyes set low on the head, with a large forehead. Older characters have eyes set higher on the face and usually have smaller eyes in comparison. In extremely stylized settings, these rules don't always apply. For example, a fully grown adult might be drawn with more childlike proportions to emphasize cuteness.

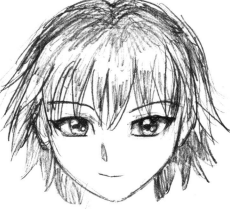

This is a more stylized woman's head. Her eyes are larger in comparison to the rest of her head, though they aren't huge. Her hair is a little more stylized as well. Her nose and mouth are simple.

Here is a semi-realistic woman's head. Her proportions are fairly natural, though a few areas are slightly stylized, such as her nose and the proportionate size of her eyes.

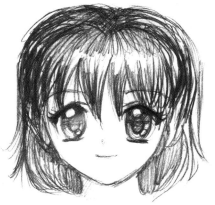

This woman's head is extremely stylized. Her huge eyes give her the look of innocence and instantaneously connect her to the viewer. Her mouth is simple and her nose is indicated with only the tiniest of lines, further emphasizing the captivating qualities of her eyes.

DRAW A CHILD'S HEAD AND FACE STEP-BY-STEP

Children have comparatively big eyes and large foreheads in relation to the overall size of the face. Note that the eyes are placed a bit more than halfway down on the overall shape of the head.

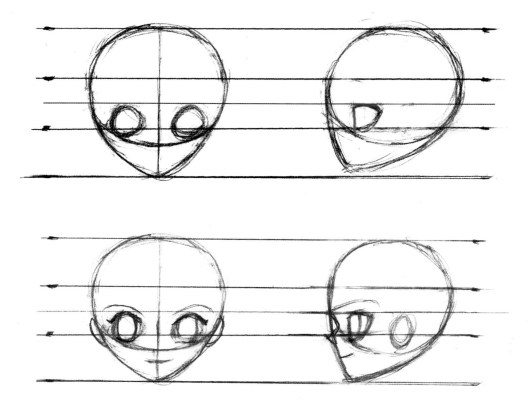

1. For both full-face and profile views, begin with five parallel guidelines, as shown, a basic circle shape, and an attached triangular jawline. The main circle should be very large compared to the jawline, and the eyes should be big and set low on the head. Draw a vertical centerline midway down the full face.

2 Define the eyes, adding a general pupil shape and the upper and lower eyelids. Keep the eyes large and set low, below the horizontal centerline. Add eyebrows and a mouth. Begin indicating the nose.

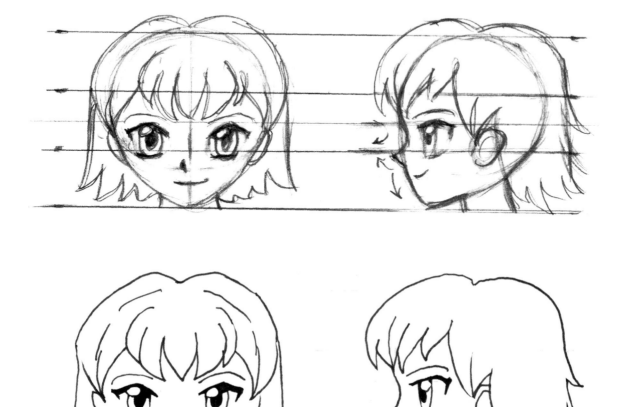

3 Add more details like pupils, irises, and highlights to the eyes; define the eyelids, ears, and nose. On the profile define the front of the face more. Draw the neck and add hair; draw the nose, keeping the distance between the eyes and nose very small. Note the direction of the curves of the profile.

4 Now finish the drawing by inking in the final lines. Once dry, erase the pencil lines.

DRAW A WOMAN'S HEAD AND FACE STEP-BY-STEP

Women in manga are usually drawn in a style reminiscent of the children's style, though not quite as exaggerated; their eyes are at mid-level, not below, for example. An older woman will have smaller eyes in relation to the rest of her face.

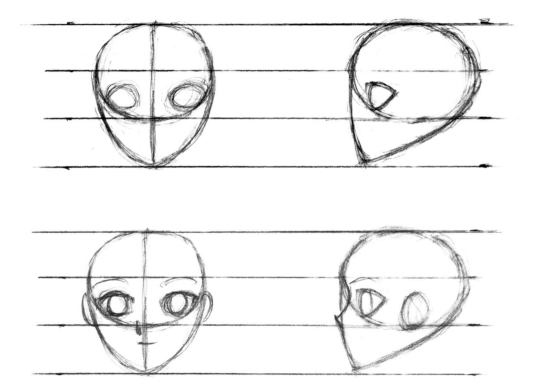

1 Begin with four equally-spaced parallel guidelines, as shown, a basic human face shape of a circle, and a jawline. Draw a vertical centerline midway down the face in front view.

2 Define the eyes, adding a general pupil shape and the upper and lower eyelids. Add eyebrows and a mouth. Begin defining the nose. Note that the eyes, ears, and nose are in the same section of the face.

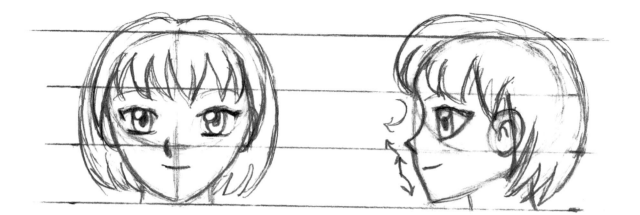

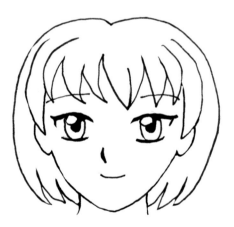

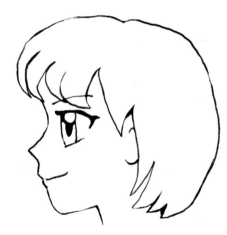

3 Add more details like pupils, irises, and highlights to the eyes, and define the eyelids, ears, and nose. On the profile define the front of the face more. Draw the neck and add hair. The distance between the eyes and nose will be slightly longer than on the child, but the curves of the face run in the same directions.

4 Now finish the drawing by inking in the final lines. Once dry, erase the pencil lines.

DRAW A MAN'S HEAD AND FACE STEP-BY-STEP

Men are often drawn with longer noses and faces than women and children. American comics artists often exaggerate men's chins but this is not always the case in manga drawings.

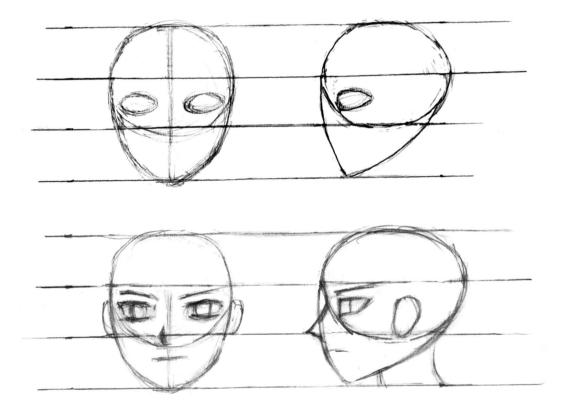

1 Begin with a basic human face shape of a circle and jawline, and note that the triangular jaw is proportionately larger than with women's and children's heads. Draw a vertical centerline midway down the face in the front view and add ovals for the eyes in the center of the head. Draw the eye on the profile with its corner touching the main circle in the bottom front and taper it slightly toward the rear part of the head.

2 Define the eyes, adding a general pupil shape, and the upper and lower eyelids. Add eyebrows and a mouth. Begin defining the nose. The nose is usually a little more prominent in a man.

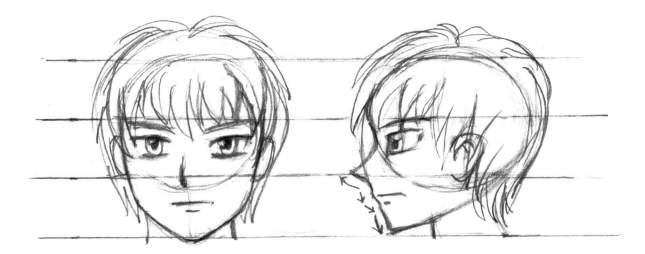

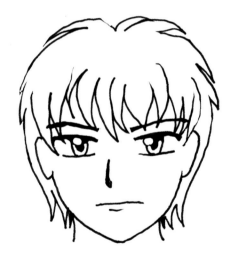

3 Add more details like pupils, irises, and highlights to the eyes, and define the eyelids, ears, and nose. On the profile define the front of the face more. Draw the neck and add hair. The distance between the eyes and the nose may appear farther apart on some male characters as opposed to female or child characters, and the profile is more angular than curvy. Note that the angles on the man's profile run in the same direction as the curves on women's and children's.

4 Now finish the drawing by inking in the final lines. Once dry, erase the pencil lines.

DRAWING HEADS AT AN ANGLE

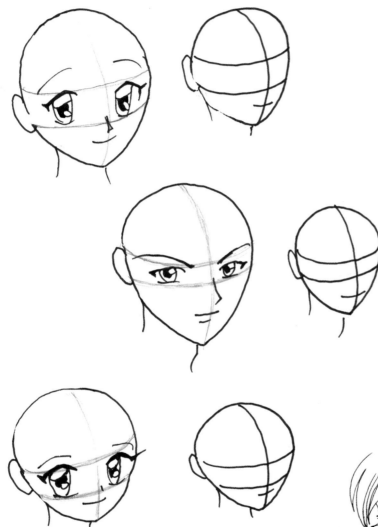

These are quarter head views, with the face slightly turned away. Note how the central two dividing lines meant to indicate the area of the eyes can vary in size and placement from head to head. On top is a woman's head, in the middle is a man's, and on bottom is a child's. Note how the child's eyes and face are restricted almost to the bottom half of the head, below the halfway line, and the eyes are comparatively huge. The mouth is small and close to the bottom line of the eyes, and the nose is just a tiny line. The man (in the middle) has the smallest eyes of the three and his mouth is the farthest away from the bottom of his eyes. His nose is fairly long. Note also the Adam's apple (a slight bulge) in the front of his throat, which is usually more pronounced in men. The woman on top is somewhere in between the two, with eyes right at midlevel and proportionately smaller than a child's, while the mouth and nose are less prominent than in the man.

Glasses give distinction to a character. They can also be used to make your character look smarter, since glasses are often associated with people who like to read and learn. Note that the placement of the glasses leaves most of the eye easily visible. Draw sunglasses for a "cool" character, or simply someone out in the sun.

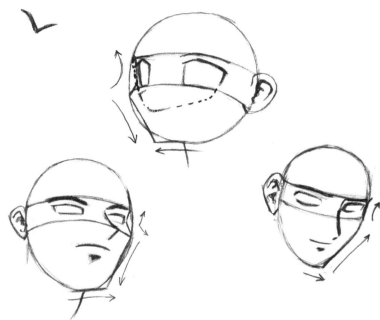

Note how the face on the top left has a jawline that is almost like a check mark. The outline of the cheek expands up and outward as it heads toward the hairline. Many manga faces are drawn at this angle (a three-quarter view). Note in the other faces how the otherwise smooth outline is sometimes interrupted by adding a little more angularity to the jaw or cheek (see arrows). Some manga artists like to draw facial outlines with a lot of sharp angles, foregoing the softer, rounded look of realism for a more stylized, angular one. Also note how the lines defining the eyes, nose, and mouth can line up with each other at certain angles (indicated by the dotted lines).

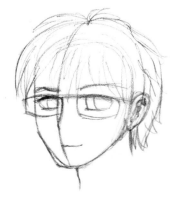

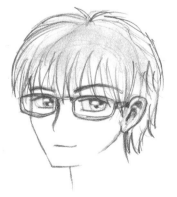

A guy wearing glasses. Remember to tuck the glasses on top of and behind the ears, unless the hair is obscuring them. Also note that the frames outline the eyes and don't block them and diminish their drawing power.

EYES

The eyes are said to be the window of the soul, and manga eyes tend to be large and expressive. There are many different ways to draw manga eyes, though, and styles range from artist to artist and story to story. Stories which tend toward more lighthearted subjects often feature cuter characters with bigger eyes, whereas more serious stories tend toward more realistically drawn characters with comparatively

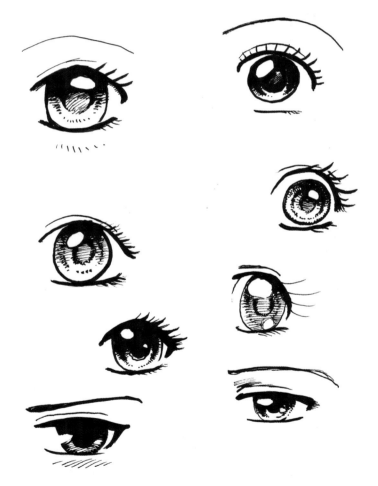

Here I've drawn several different examples of manga eyes. Some feature darkened pupils and others keep the pupil light in shade. Some have simple irises and others feature more detailed, elaborate ones. Most of these are women's or children's eyes but the bottom two could potentially be men's, because they are relatively smaller and less round in shape. Note how all of the eyes have incomplete outlines, leaving the outside and/or inside corners undrawn.

smaller eyes. Manga and anime eyes are often drawn with broken or incomplete outlines. The top and bottom eyelids/lashes will be drawn, but quite often the outside and/or inside corners are left unfinished. If colored in, there will usually be a difference between the color of the eyeball and the face, however.

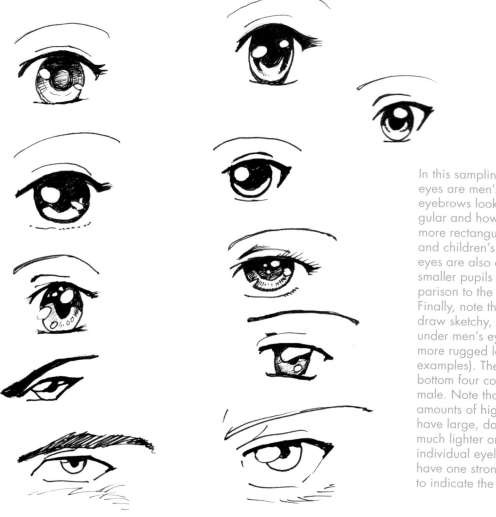

In this sampling, the bottom four eyes are men's eyes. Note how the eyebrows look thicker or more angular and how the eyes are a little more rectangular than the women's and children's eyes above. Men's eyes are also often drawn with smaller pupils and irises in comparison to the rest of the eyeball. Finally, note that sometimes artists draw sketchy, cross-hatched lines under men's eyes to indicate a more rugged look (the bottom two examples). The six eyes above the bottom four could be male or female. Note that they have varying amounts of highlights. Some eyes have large, dark pupils and others much lighter ones. Some show individual eyelashes and others have one strong, thick, stylized line to indicate the eyelashes.

DRAW WOMEN'S AND CHILDREN'S EYES STEP-BY-STEP

Here's a breakdown of the process for drawing captivating eyes, perhaps the most important element of communicating your character's personality.

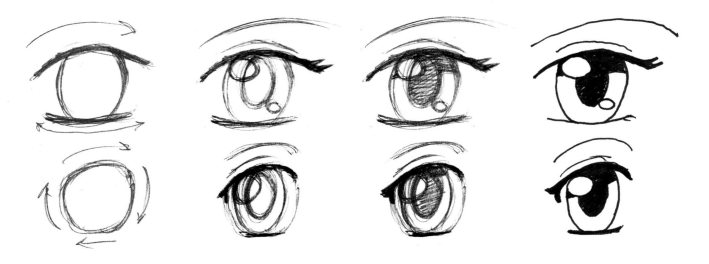

1 Block in a basic shape for the eye and the iris. Use the arrows as guides to help you determine whether the lines they indicate are straight or curved; the lines for these eyes are more curved. Note how on the top eye, only the top and bottom eyelids are shown and the corners of the eyes are not drawn. The lids are not yet indicated on the bottom eye so you can pay particular attention to the shape (see arrows).

2 Add more details like the pupils, highlights, and eyelashes. Block in the eyebrow and crease on the upper eyelids.

3 Shade in the pupils and upper eyelid's shadow and further define the eyelashes and lash lines.

4 To finish the eyes, ink in the details and erase the pencil lines once the ink is dry.

DRAW MEN'S EYES STEP-BY-STEP

The process for drawing men's eyes is the same as for women's and children's eyes. The difference is in the details of the shapes, proportions, and lines.

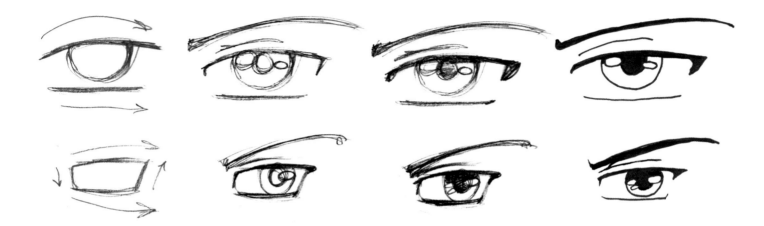

1 Block in a basic shape for the eye and the iris. Use the arrows as guides to help you determine whether the lines are straight or curved; men's eyes have more straight lines overall.

2 Add details like the pupils, highlights, and eyelashes and lash lines. Block in the eyebrows and creases on the upper eyelids.

3 Shade in the pupils and upper eyelid shadows. Further define the eyelashes and lash lines.

4 To finish, ink in the final lines of the eye and erase the pencil lines once the ink is dry. The bottom eye was drawn with the usual method of leaving the corners of the eye blank, but the complete outline could have been drawn if desired.

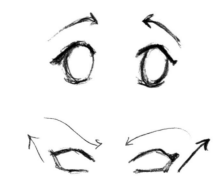

The shape of a character's eyes can also provide a clue to his or her personality. The eyes on top are rounded and the outside corners droop slightly. Characters with eyes depicted like this tend to look innocent, shy, or younger. The eyes on bottom are slanted upward on their outer corners. Characters with eyes depicted like this can be seen as mischievous, outgoing, or sometimes more mature. These are guidelines, though, not ironclad rules.

DRAW NOSES STEP-BY-STEP

In general, men's noses are longer, larger, and drawn with heavier lines than women's and children's noses

 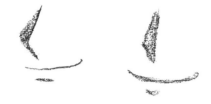

1 To draw a simple nose, start with a line, angled (as at left) or straight (as at right), to indicate the nose. Draw a simple two-line mouth below it

2 You can create extra dimension by adding a small shadow.

DRAW MOUTHS STEP-BY-STEP

Mouths, like noses, are generally drawn with a simple line or two when closed. The shape of the mouth line can indicate personality or emotion, like the "w" shape of a playful young girl or the short, sharp line of a skeptical man.

1 Draw the outside of the mouth.

2 Add a curved line to indicate the tongue.

3 Shade in the inside of the mouth.

DRAW EARS STEP-BY-STEP

Detailed ears are usually only drawn on side views of the head. Note the near-egg shape, tapering a bit at the bottom lobe, and the overall roundness of the lines.

1 Draw the outline of the ear in the direction as shown by the arrow.

2 Add the crease inside the ear and shade as needed.

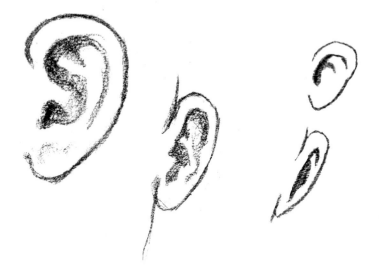

3 Some ears from different angles, ranging from realistic to cartoony.

HAIR

Manga and anime hair tends to be distinctive and stylized. The hair of animated characters is often especially stylized, even to the point of defying the laws of gravity, but manga hair can stand out beyond the ordinary as well. Sometimes hair is drawn in a particular style all on its own, without adornment, and other times the artist will add accessories such as barrettes, ribbons, bows, headbands, scarves, and hats.

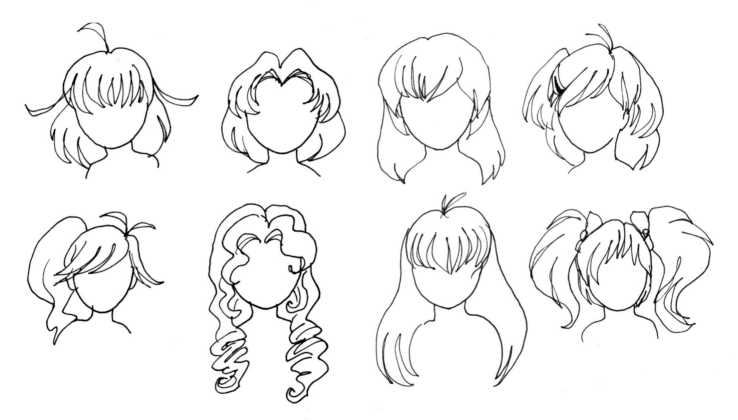

Here are examples of hairstyles one might find on a female manga character. Use these as launching points for your own character design. You can go for a realistic look or be as wild as you like! You can use little strands or wisps of hair sticking out at unusual places to add a distinctive look.

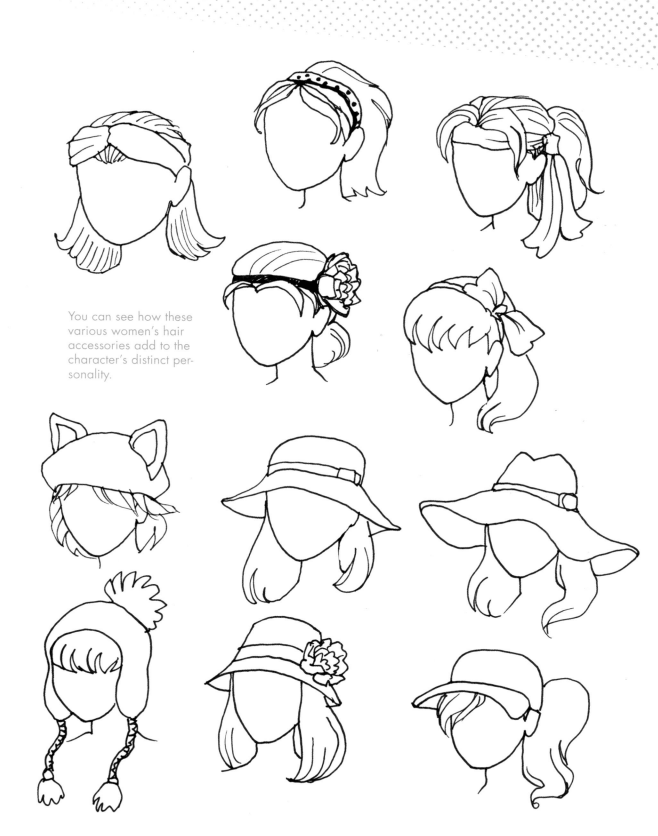

You can see how these various women's hair accessories add to the character's distinct personality.

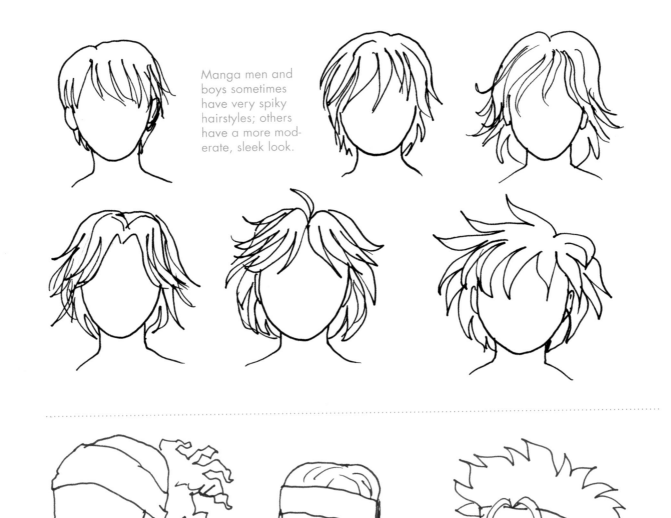

Manga men and boys sometimes have very spiky hairstyles; others have a more moderate, sleek look.

As with women, men's head and hair accessories lend additional personality to a character.

ANIMALS

Here are some step-by-step drawing demonstrations featuring two animal heads: a chibi cat head and a slightly more realistic cat head. I chose the same species so that the differences between the two styles might be more apparent. The cuter chibi head has larger eyes in comparison to the rest of its face.

These cat heads can form a basis for other animal heads. Change the nose, muzzle, and shape of the ears or eyes to draw different species.

DRAW A CHIBI CAT HEAD STEP-BY-STEP

The cute quality of the chibi cat head is emphasized by its relatively larger eyes and comparatively smaller mouth and nose, placed closer to the eyes than with a realistic cat.

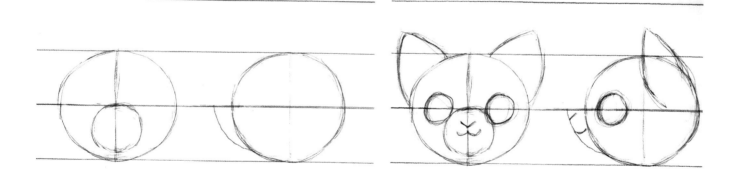

1 Draw four equidistant parallel, horizontal lines. Draw a circle for the head, placed evenly between the lines (as shown). Add a smaller circle (for the muzzle) under the horizontal centerlin. For the side view, use the centerline to guide your depiction and placement of the muzzle.

2 Add circles for the eyes using the centerline as a guide. Add the simple nose, mouth, and ears as shown. Note that the side view facial elements are in the same proportion as the full-face view.

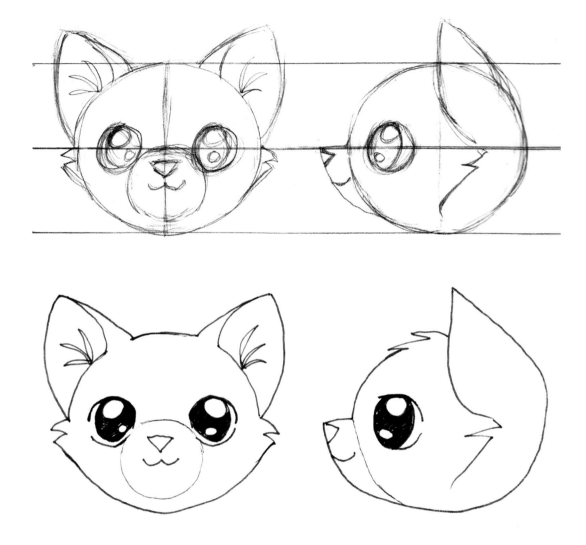

3 On both the front and side views, continue adding details to the face, such as further definition of the nose, the pupils and highlights, and the cheek fur. On the front view, add details to the interior of the ears.

4 Now finish the drawing by inking in the final lines. Once dry, erase the pencil lines.

DRAW A SEMI-REALISTIC CAT HEAD STEP-BY-STEP

Though you begin them exactly the same way, note how the nose of this semi-realistic cat is placed slightly below the eyes, while the chibi's nose is placed directly between its eyes.

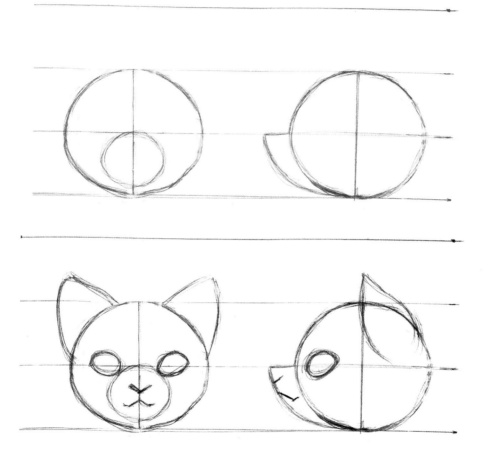

1 Begin by following step 1 of the Chibi Cat Head (page 59).

2 For both the full-face and side views, add slanted ovals for the eyes using the horizontal centerline as a guide. Add ears, noses, and mouths, noting their placement.

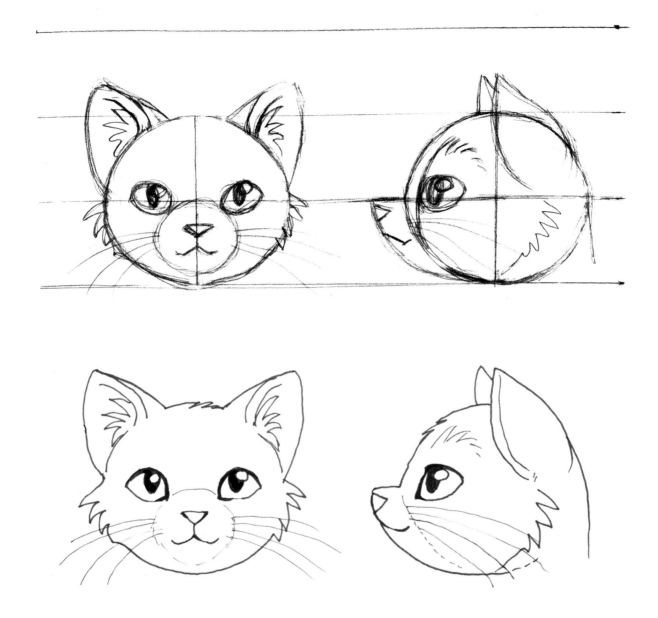

3 Continue adding details, such as fur along the cheek ruffs, the pupils and highlights of the eye, details of the ears, and the top of the nose. Add whiskers. On the side view, add some indication of fur along the muzzle and up across the eyes.

4 Now finish the drawing by inking in the final lines. Once dry, erase the pencil lines.

DRAW A PUPPY HEAD STEP-BY-STEP

Here we'll draw another chibi animal head, this time a puppy.

1 Sketch a circle for the head and divide it into four equal quadrants with horizontal and vertical centerlines.

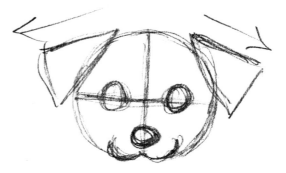

2 Add eyes on the horizontal centerline, and a nose and mouth close to the bottom of the circle. Add slightly angled triangular shapes for the ears, as shown.

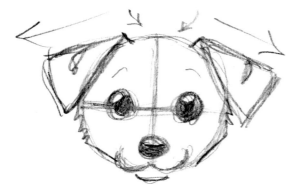

3 Visually attach the ears to the head by making short lines around the inside and outside edges of the triangle. Fill in the eyes, adding a pupil and a highlight to each one. Fill in the nose, leaving a highlight, and add creases to the ears.

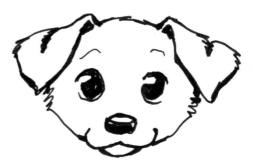

4 Now finish the drawing by inking in the final lines. Once dry, erase the pencil lines.

DRAW A FOX HEAD (SIDE VIEW) STEP-BY-STEP

Here is yet another common chibi, the fox, this time drawn in the side view.

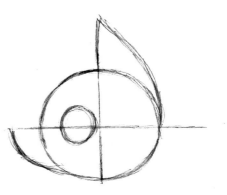

1 Sketch a circle for the head and divide it into four equal quadrants with horizontal and vertical centerlines.

2 For the muzzle, follow the curve of the bottom of the circle and sweep up in an arc from the bottom of the circle, stopping at the horizontal centerline. Add an eye, placing it inside the vertical centerline and centering it on the horizontal centerline. Finally, add an ear by drawing a line that sweeps up from the center of the circle on the right side above the top of the circle, and stopping at the (extended) vertical centerline, as shown.

3 Add a pupil and highlight to the eye and add a triangle-shaped nose. Add the ear on the far side (behind the one added in step 2) and indicate the front and back of the front/closest ear with another, slightly curved vertical line. Then add a cheek fur ruff by sweeping a line from the front of the closest ear (center top of the head) down to the vertical centerline on the right. Then use some zigzag strokes to connect it with the bottom of the head, as shown.

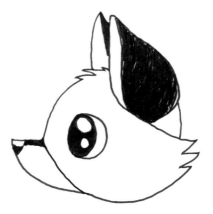

4 Now finish the drawing by inking in the final lines. Once dry, erase the pencil lines.

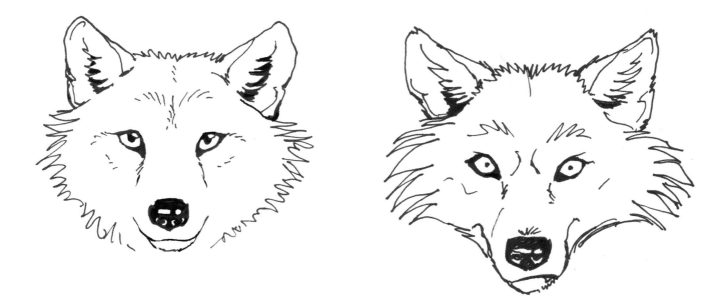

The same animal can look quite different depending on how you design it. These two heads are both wolves, but the one on the left is a more "hero" character and the one on the right more of a "villain." The hero wolf is softer and rounder. His features are more even and full and more realistically proportioned. His eyes are "kinder," too—pupils are larger and highlights prominent. In contrast, the villainous wolf is haggard and sharp in appearance. The fur is spikier, and the muzzle is comparatively larger and longer. The eyes have a colder, more piercing look, obtained by drawing very small pupils with no highlights. The lines between the eyes suggest a furrowed brow, an angrier expression.

DRAW ANIMAL EYES STEP-BY-STEP

Here we'll draw various animal eyes in differing styles, all front views. In each of the drawings for the four steps, the eye on the left is more cartoon-like; the eye in the middle has a slightly vertical pupil and could belong to a cat or a fox; and the one on the right, with its placement more on the side of the head, could belong to a deer or a horse.

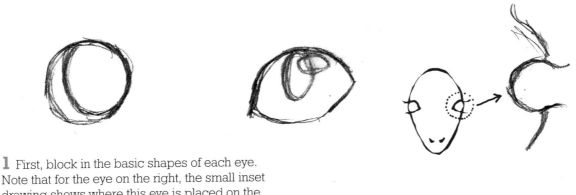

1 First, block in the basic shapes of each eye. Note that for the eye on the right, the small inset drawing shows where this eye is placed on the head.

2 Continue by adding details like pupils, highlights, and eyelashes. For the eye on the right, draw a curved outer line, as shown, to indicate the curve of the eyeball (the dotted line indicates the placement of the eyeball within the head).

 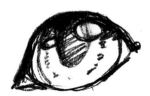

3 Add more details to the eyes, shading in pupils and adding eyelashes or details to the iris. Note that the eye on the right has a horizontal pupil like a deer or horse.

 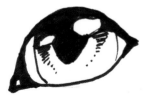 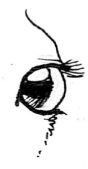

4 Now finish the drawing by inking in the final lines. Once dry, erase the pencil lines .

3 EXPRESSIONS

Expressions add life and interest to your character. The most obvious expressions are facial ones: emotions like happiness, sadness, anger, etc. However, there are other ways to further define your character's expressions using accessories like clothing, feathers, and fur. This chapter takes a look at some of the most common expressions or some of the most unique ways of showing those expressions in manga.

This girl's entire demeanor is happy and comfortable. She brings a hand up playfully to her chin. Everything about her seems relaxed and at ease.

EMOTIONS

Emotions are an important means of communicating a character's mind-set to the audience. The size, shape, and relationship of the eyes, mouth, and other features can show a range of expressions and moods. There are also certain symbols, like the sweat drop, that convey emotions in a way that is peculiar to manga and anime.

HAPPY

Happy characters have big smiles, bright eyes and often look energetic. Eyes may be wide open or they may be slightly crinkled by a huge grin pushing their cheeks up.

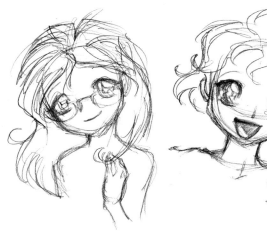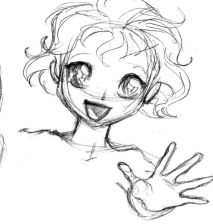

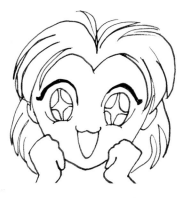

This character has a starry-eyed look, like someone in awe or in love. Note the star-like shape inside the pupils, obscuring their normally dark tone. Starry-eyed characters are extremely happy and often enamored with something or someone.

Both of these girls are happy, but the girl on the left has a quieter look while the one on the right seems much more outgoing. The quieter girl has a closed smile and is shyly twirling her hair, head cast slightly downward. The outgoing girl is reaching toward the viewer, mouth open with excitement. Subtle differences can tell the viewer not only whether the character is happy, but give clues to their personality or particular frame of mind.

A happy character might wink, too. Here the lashes of the winking eye are drawn extra thick and two small, stylized highlights indicate a merry sort of sparkle.

DRAW A HAPPY GIRL STEP-BY-STEP

Here we'll draw a happy girl in six simple steps. Her happy state is expressed with a wide-open gaze and a completely relaxed body posture.

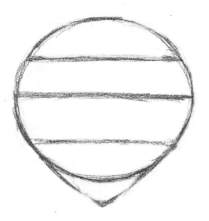

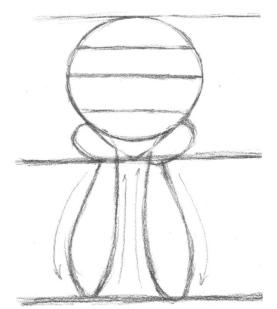

1 First draw a circle, then divide it into quarters horizontally. Add a triangle shape at the bottom for the chin, making sure it's not quite a quarter-length below the bottom of the circle. Be sure to leave at least another head-length of space below this chin shape.

2 Now add another head-length of space below the first (from step 1), drawing horizontal lines to guide you. Draw two oval shapes abutting the triangle to indicate the hand resting on the jawline and slightly baseball bat–shaped arms propping up those hands. Keep slightly less than one arm length between the arms.

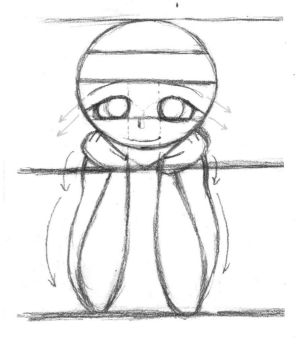

3 Give detail to the arms and slightly round the shoulders. Indicate the fists the chin rests on. The bottoms of the eyes (and pupils) sit on the bottom guideline as the lower eyelids. Eyebrows are at the middle line and the upper eyelids halfway between the lower lids and eyebrows. The space between her eyes is slightly less than one eye length. For a wistful expression, give the outer corners of her eyes and eyebrows a slight droop. Block in the irises. Indicate her nose with a small mark just to the left of the center. Her lower lip aligns with the bottom of the head circle and her mouth is just a bit above that. The width of her mouth equals the space between her eyes.

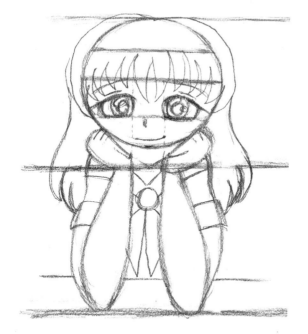

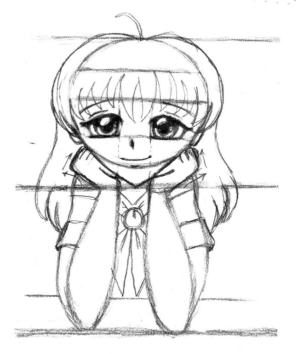

4 Now add hair, giving it volume over the head shape and curving down from the top of the head. Add pupils and highlights to the eyes and define the outlines of the eyeballs. Add small lines above her eyes to indicate the crease of her eyelids. The girl's elbows rest on a table, so draw a horizontal line slightly above the lowest line to indicate where her body rests against the table edge. Draw the sash, bow, and sleeves of her sailor uniform.

5 Further refine the eyes, making sure the pupils and shadows caused by the upper lid are shaded in. Darken and thicken the eyelashes for a striking effect. Indicate wrinkles in clothing and add the ears on the sides of her head. I made the knuckles of her hands more square (indicated with arrows). Finally, add a sprig of hair on the top of her head.

6 The final step is to ink in the lines. I ended up adding a third highlight to each eye as I inked them. Don't ink in the entire outline of the eyeball. Instead leave some white spaces in the corners of the eyes for a more manga-style look. Ink in the final lines, let the ink dry, then erase the pencil marks.

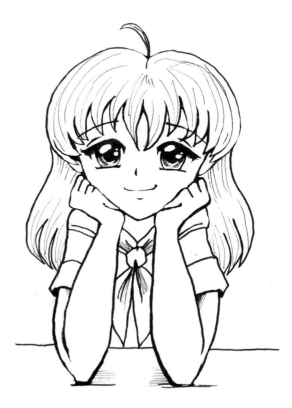

SAD

Sad expressions can be shown with frowns, tears in eyes, or eyebrows pointing up and toward the top center of the forehead. The tilt of the eyebrow and a general tension of the face can cause the eyes to narrow from stress. Tears are semitransparent and pool on the lower eyelid, falling out of either corner.

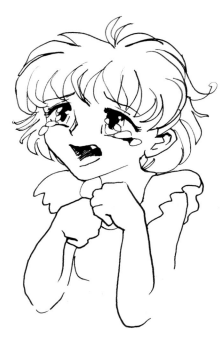

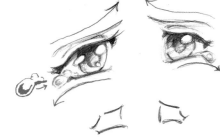

Sad characters' faces may range from a simple frown to something more dramatic. This girl is quite distraught. She is crying, her mouth is open with a sob or protest, and her arms and hands are clutched up to her chest. There is no question she is very sad.

The face on top left is your basic sad face. It has a frown and worried eyes. The arrows on the drawing on the bottom right emphasize the primary directions of the eye and eyebrow lines. The eyebrows and the top of the eyelids should furrow upward toward the center of the face. The bottom eyelids may bunch up in a curve as shown.

Tears can take some practice to get right. Note that multiple highlights have been added to the eye for a moist appearance. Tears are indicated by globular drops coming from the outside corners. Some shading was added as almost C-shapes near, but not exactly on, the edges. The inner eyes furrow up to the center top, while the outer corners pull down and out.

Here, more tears are streaming from an eye. There are rounded tears along the bottom lid and one long stream coming down from the corner of the eye and trailing down the cheek.

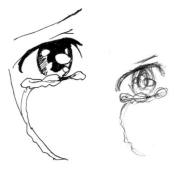

ANGRY

Angry faces have eyebrows that furrow down and a scowl or open, yelling mouth. Extremely angry manga characters may be shown with open mouths with lower lip outlines that extend to the jawline or below it. Teeth may be exposed in a grimace, and some artists will draw a stylized canine tooth for an extra snarly look.

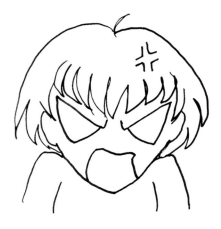

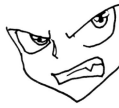

Here are two angry faces. The one on the left has the exaggerated open mouth dropping to chin level and has become so shocked/angry that the eyes are almost triangular and have no pupils— another manga indication of an extremely agitated person. The angry character at right reveals a snarly-looking canine tooth.

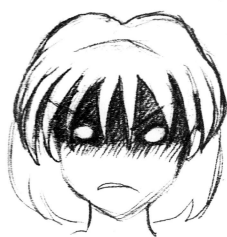

This is the angry/scary face. A dark cloud falls on the upper half of the face and the eyes have become white orbs with no pupils. This is an extremely angry character (though she may appear otherwise quiet and still in her body language). This is the "calm before the storm." You can see in her expression and the dark shading that she's about to explode into angry rage unless something changes very quickly.

DRAW AN ANGRY FACE STEP-BY-STEP

This angry character encompasses several classic anger traits, including the slant of her eyebrows, the sharp shape of her mouth, and the prominent canine tooth.

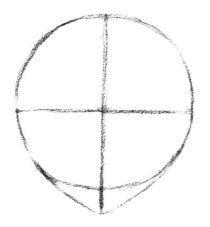

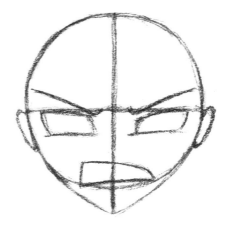

1 Draw a circle and divide it into equal quarters. Add a small chin on the bottom, tapering to a point underneath the circle.

2 Add eyes. Give them a tense, squinting look by gently sloping the top eyelids down toward the center and drawing a slight, subtle curve to the lower. Add the scowling mouth. The curve at the bottom of the eyes makes the cheeks look like they're bunching up from the grimacing mouth below. Note: this scowl makes one side of the mouth wider than the other and the bottom corners of the mouth touch the bottom of the head circle. Add furrowed eyebrows (they look like check marks). Use the horizontal centerline to place the ears.

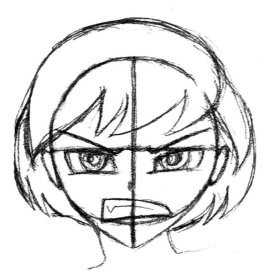

3 Add details, including the eyes, pupils and irises, and a fang inside the mouth. Add a small line just above the mouth to indicate the nose. Draw hair and the neck.

4 Now finish the drawing by inking in the final lines. Once dry, erase the pencil lines.

ANNOYED AND IRRITATED

Annoyance and irritation are emotions that are closely related to anger. They are characterized by a plus sign–shaped mark on the character's forehead.

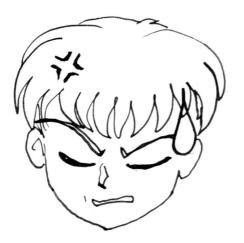

The "anger mark" of irritation (inset) is a standard in manga emotions. This plus sign–shaped mark appears on a character's forehead when they are irritated or annoyed. Sometimes a character closes his eyes like he is trying to distance himself from foolish things, but the anger mark on the forehead gives away the fact that he is growing increasingly annoyed.

CONFUSED/DOUBTFUL

A doubtful or confused character might stand with mouth agape. Like the angry yell, the outline of the mouth may drop down in astonishment to (or even below) the jawline. Eyebrows will be furrowed or raised. This expression may feature a "sweat drop," which is a tear-shaped bead of moisture dripping down the forehead in a stylized manner.

A sweat drop (upper left) indicates the character is uncomfortable, embarrassed, or not quite sure what to do next.

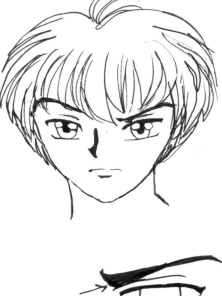

This boy is also doubtful, showing the same pattern of one eyebrow up and one down as the girl at left. His mouth is more of a flat frown, however. Note how his furrowed eyebrow touches the top crease of his eyelid.

This girl looks doubtful. One eyebrow is furrowed down like she's sad and the other is raised up as if in surprise. Her mouth has the same tilt as her eyes, reinforcing the doubt.

ACCESSORIES

Clothing and accessories can add to the expressions of your character. Someone who wears a hood or hat may sometimes have part of her face concealed, depending on the angle of her head. A partially concealed face can add a mysterious, guarded, or secretive look to a character. The rim of a hat over a downcast face might read as sadness, while another character uses his hat to wave it in the air in jubilation. Since accessories have to be drawn again and again, use them wisely.

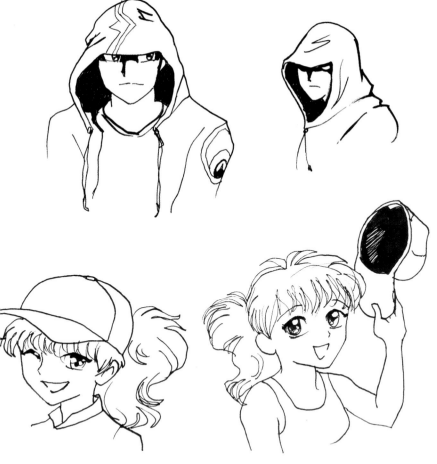

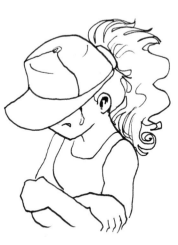

Note how the hood of this man's jacket drops over his face, creating a slightly mysterious look.

This girl's hat adds to her expressiveness. The drawing far left shows her in a more neutral view. At near left, she waves her hat excitedly, but then is sad and crying above. (By drawing her head downcast, the hat's brim hides her face and makes her seem like she's trying to hide her sorrow and withdraw from the world).

EXAGGERATING FEATURES

Animals are a great example of how one can exaggerate features to convey personality. Amplifying the features of an animal's head can help you more easily express their emotions as well as create a more appealing (or menacing) look.

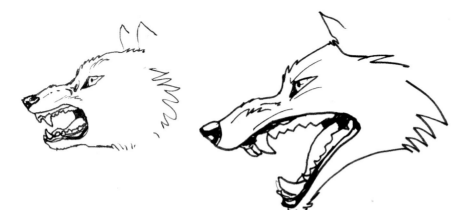

A snarling wolf drawn realistically (left) and more manga-style (right). Note how I exaggerated the muzzle of the the wolf on the right, making it much longer and bigger than the realistic wolf. Exaggeration allows an artist to emphasize character-defining features like its sharp teeth and the curve of its lips. The larger-than-life mouth also makes it look more menacing.

Here are three drawings of the same species of fox, but each one a distinct personality. The fox on the left is more average, a fairly pleasant design for a character that might be neutral in nature. The fox on the right is a little more intimidating, with its long, sharp muzzle, a mouth full of sharp teeth and ears that curve up in a way that could subliminally suggest devil's horns. This might be a villain. On the bottom is a very cute fox, with a short muzzle, large eyes, and rounded forehead—all indications of a sympathetic character.

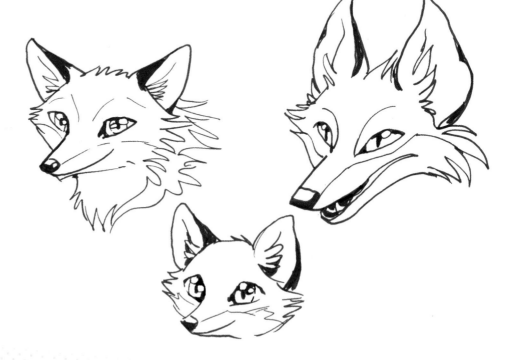

USING FUR, FEATHERS, AND SCALES

An artist can use details like pronounced feathers, fur, or scales to add design elements and personality to animal characters.

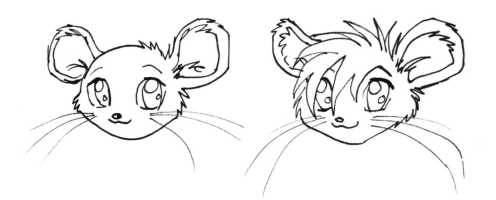

These two mice are basically the same, except that one has a big tuft of fur overhanging his fore-head, like human bangs. This illustrates how a little touch can provide extra visual description to your character. The scruffier the "bangs" look, the more messy and casual the character seems. The smooth and clean look of the mouse on the left suggests she might be a little more prim and proper.

Though both birds are similar, the one on the left has a softer, fluffier look with a more innocent expression, communicating unthreatening friendliness. The bird on the right has a sharper expression with smaller eyes, a closed mouth, and spikier feathers. The tuft on its head looks like a Mohawk, suggesting a tougher character.

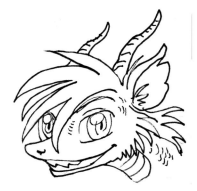

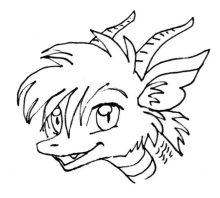

These dragons look enough alike to be twins, if one was the evil twin. The scarier dragon at left has longer, spikier muzzle, longer scales (bangs), and a fiercer face with a bigger mouth and sharper teeth. The friendly dragon at right has a shorter, more baby-like muzzle and more rounded features, which give it a friendlier appearance.

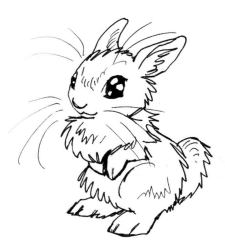

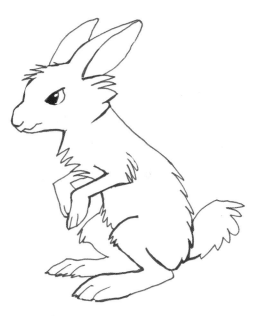

The same animal can be designed differently to make it seem more appealing, or less so. Extra poufy fur and rounded shapes add a cute and cuddly quality to this rabbit.

This rabbit, while not exactly fierce looking, has a less cuddly and soft appearance, thanks to the more angular body and limb shapes, skinny legs, a longer nose, and smaller eyes in relation to his head.

DRAW TWO RABBITS (SIDE VIEWS) STEP-BY-STEP

Here is an example of how you can draw the same animal but create two different looks, as with these two rabbits.

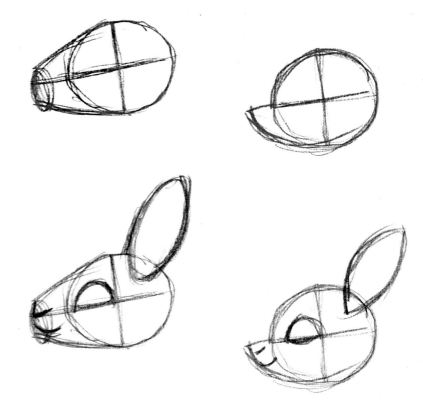

1 First draw two circles and divide them into equal quadrants. The rabbit at left is semi-realistic (with a longer muzzle that extends from its whole face), while the one at right is more stylized (with a much shorter muzzle that stops at the center dividing line, giving the appearance of a large forehead).

2 Add in the ears, eyes, nose, and mouth.

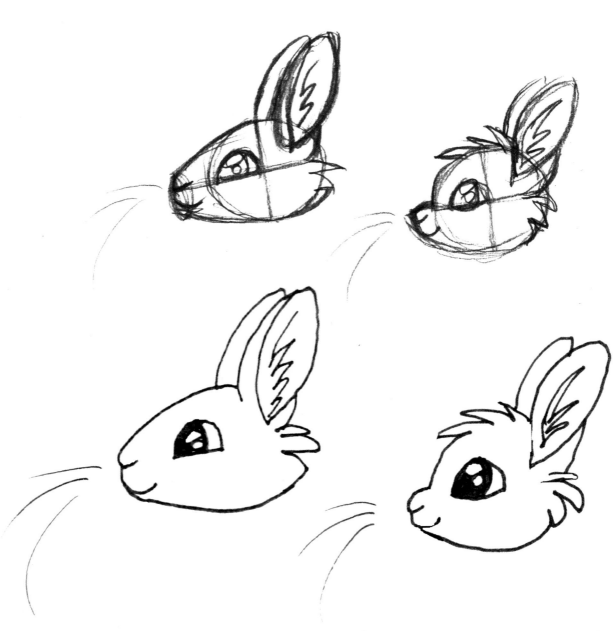

3 Continue adding details, including hair tufts inside the ears, pupils and highlights in the eyes, and zigzag lines indicating fur on the cheeks. Give the chibi bunny on the right a tuft of hair coming from its forehead. Add whiskers to both.

4 To finish, ink in the final lines and erase the pencil lines.

PERSPECTIVE

The pose and angle in which you put your character influences the viewer's perception of that character. Viewing angle can be used to create a sense of power or vulnerability in the viewer, which can influence how they relate to the character.

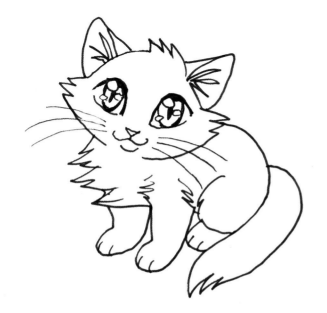

This is the same kitten, drawn from different angles. The kitten on the left is drawn from the perspective of someone tall looking down at a small kitten, making it seem younger and more vulnerable. The kitten below is from the point of view of a mouse looking up at the cat looking down at it. From this angle the cat appears bigger and more threatening.

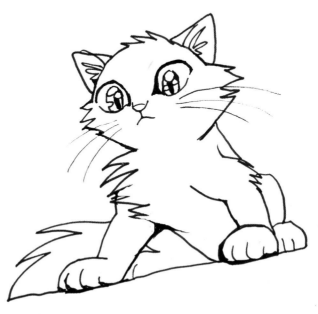

ANIMAL EXPRESSIONS

The same basic expressions that you use to convey emotions in humans are applicable when drawing cartoon animals as well. Follow the same basic guidelines.

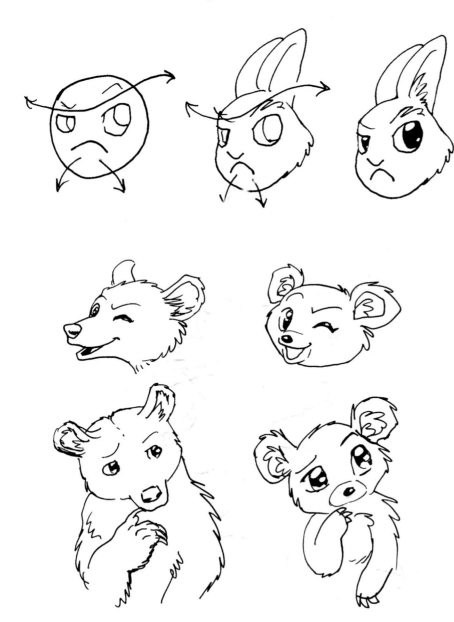

The human figure (directly below, left) is made to look happy with her smile and the relaxed lift of her eyebrows. You can create the same happy effect with an animal, by drawing the same upturned corners of the mouth. You can reinforce this by using fur, feathers, and other features to emphasize the same uplifted area above their eyes. At far left, the human's doubtful look, achieved by furrowing one eyebrow and lifting the other, can be drawn on the rabbit to his right by using fur shapes, instead of line eyebrows, to suggest the same expression. The mouth is kept in an exaggerated frown as well.

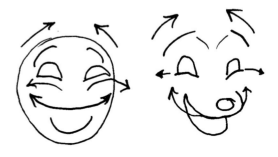

The same expressions hold true no matter how stylized or realistic the animal. Here a more realistic bear (far left) and a chibi bear (left) have the same expressions, gestures, expression of the eyes and mouth, and therefore show the same emotions and personality traits. A happy mouth, for example, will have uplifted corners whether it is on a long muzzle, a short one, or no muzzle at all.

DRAGONS

Dragons are an example of an animal that lends itself to a variety of styles. As mythological creatures, they are bound only by the artist's own imagination, and manga dragons can have all sorts of scales, wings, horns, fur, and other features.

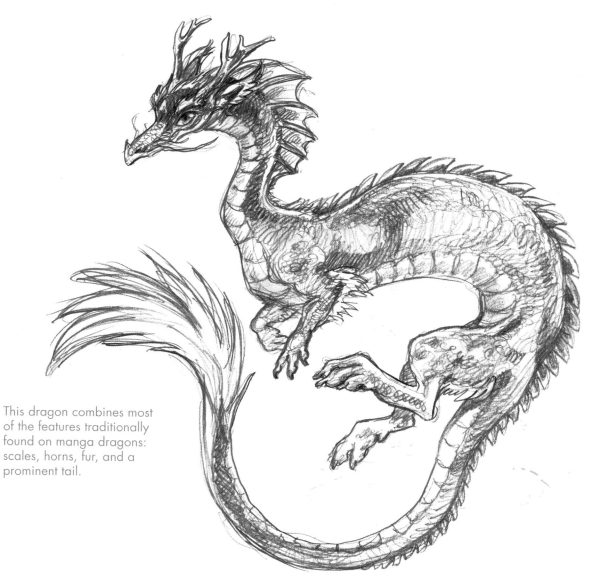

This dragon combines most of the features traditionally found on manga dragons: scales, horns, fur, and a prominent tail.

DRAW TWO DRAGONS (SIDE VIEWS) STEP-BY-STEP

Here is another example of how the same animal can be drawn in a different way to achieve a different type of character. The dragon at left is more realistic while the one on the right is a cute chibi-style dragon.

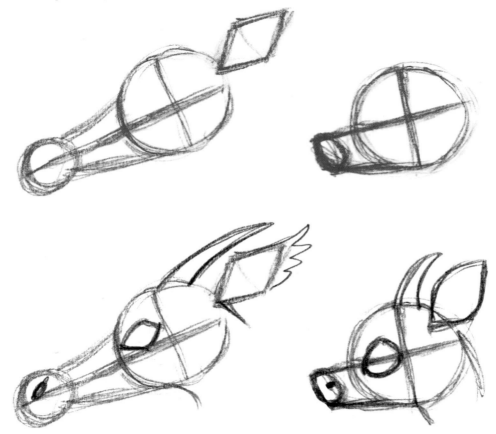

1 Draw two circles and divide them into equal quarters. Add a long muzzle to the more realistic dragon on the left and a shorter muzzle to the chibi-like one on the right, drawing small circular shapes on the tips for noses. Add a diamond-shaped ear to the realistic dragon on the left.

2 Add eyes, nostrils, and horns to both dragons, and add the ears to the chibi dragon on the right. Note that the eye of the realistic dragon (at left) is contained within the top left quarter of the head circle. The eye of the chibi dragon on the right is comparatively much larger and is situated on both the top and bottom left quarters of the head circle.

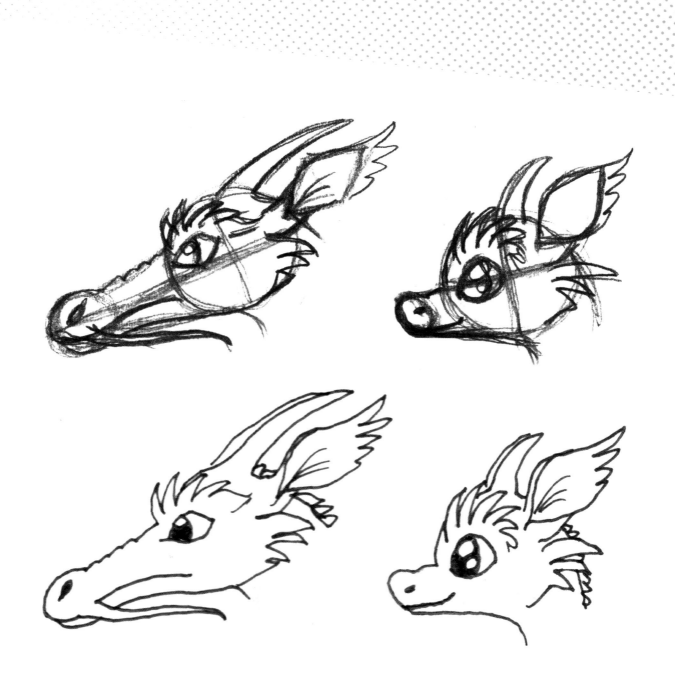

3 On both dragons, add pupils and highlights to the eyes. Draw in hair on the cheeks, and tufts on the ears and above the eyes. Draw whiskers on the realistic dragon (at left).

4 Now finish the drawing by inking in the final lines. Once dry, erase the pencil lines.

4 BODIES AND GESTURES

The head, face, and eyes are important parts of any character, but the body is the whole package. Bodies and gestures can be used to tell a viewer a lot about a character and what they're thinking or doing. There are many different ways to approach drawing a figure and the examples provided in this chapter are only a few of them. Try these and also experiment with your own methods.

This cheerful girl looks ready to go to the beach.

BASIC ANATOMY

Understanding basic anatomy is very important when it comes to drawing bodies and gestures. An artist needs to understand how underlying structures relate to one another when a body moves in order to convey that movement in artwork.

Anatomical studies help even when drawing something more cartoon-like. Skilled cartoonists understand body structure enough to be able to break it down into stylized forms that still look believable and interesting.

You can use this simplified human skeleton to study both skeletal and muscular structures to improve your drawings, whether you're drawing realistic or cartoon characters.

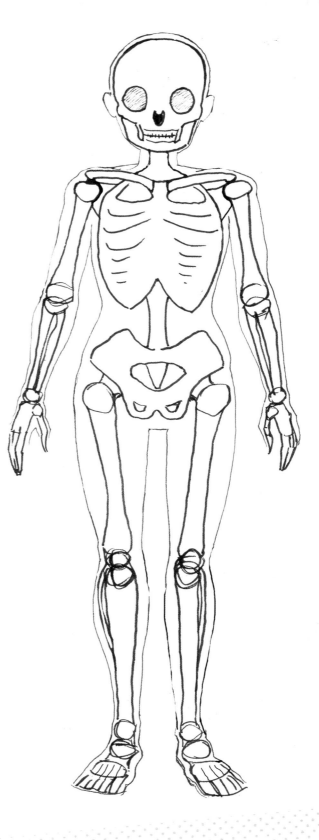

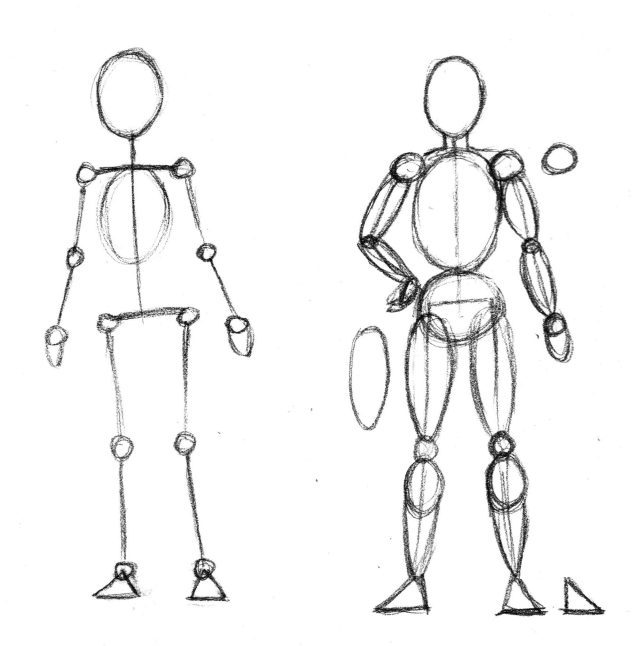

On the left, simple straight lines represent the major bones of the body while small circles represent the main joints. On the right, the basic structure has been fleshed out a little bit with the use of circles, ovals, and triangles to indicate basic muscle structures of the body.

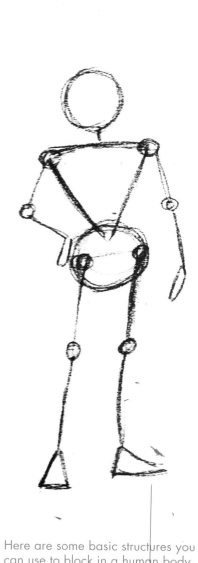

Here are some basic structures you can use to block in a human body, whether it is simply with lines, or with combinations of lines, circles, ovals, triangles, and related shapes. Each artist finds something that works best for her. Try different ones and see which work best for you.

ANATOMY OF A CHIBI, CHILD, WOMAN, AND MAN

The human body is often measured in head lengths—i.e., the total length of the human head from top to bottom. Adult bodies are usually drawn six to eight heads tall. A taller character (say eight heads tall) would seem more elegant, dramatic, or dominating. A shorter character (say five heads tall) would seem smaller, unthreatening, and cuter. Children's bodies tend to be about four to six heads tall, depending on age and drawing style, and chibis may be only two heads tall. The proportions of characters can vary from artist to artist and story to story. The main thing is to decide on a specific proportion for your character and then stay consistent with it.

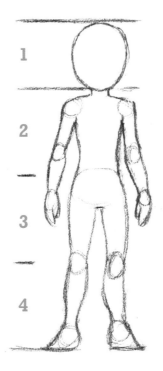

This chibi is drawn at two heads tall, with its entire (very simplified) body the same length as its head.

This typical child is drawn at four heads tall. Children's bodies haven't yet developed the muscles and proportions of adults, so they are often drawn with fairly straight outlines.

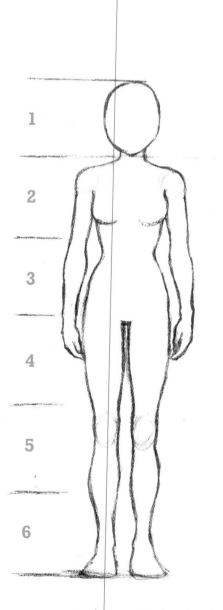

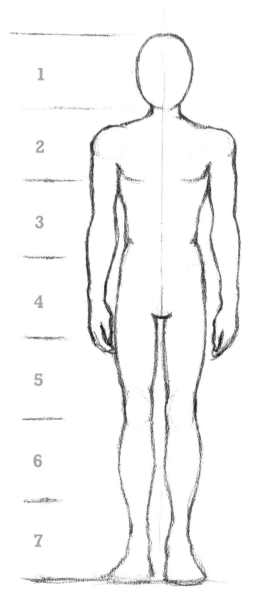

1

2

3

4

5

6

1

2

3

4

5

6

7

This average woman is drawn at six heads tall.
Women generally have wider hips and narrower
shoulders than men, and proportionately longer legs.

This average man is drawn at seven head lengths tall.
Note that while body types differ, men typically have
broader shoulders than women, and narrower hips.

DRAW A BISHOUNEN STEP-BY-STEP

Bishounen is a Japanese term meaning "beautiful boy" and often used in manga and anime to refer to handsome boys or young men. The male in this example is seven heads tall.

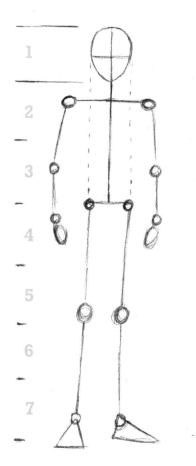

1 Draw an oval, slightly tapered at the bottom, for the head, then divide it into equal quarters. Measure down seven head lengths from the bottom of the head, as shown, making the figure a total of seven heads tall. Next, block in the basic frame of the body with a simple stick and joint technique. Note that the hips are about the same width as the head (indicated with dotted lines) and three heads down from the head. Use triangle shapes for the feet and basic ovals for the hands.

2 Begin fleshing out the character with oval or teardrop shapes to represent the lower arms, thighs, and calf muscles on the lower legs, and an oval for the chest and hips. Add circles to flesh out the shoulders more. On the head, block in the eyes, eyebrows, nose, mouth, and ears.

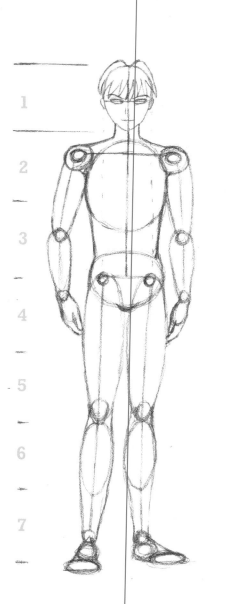

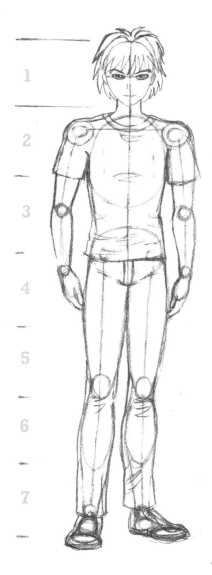

3 Add hair and bangs to the head, creating a loose "m" shape at the top. Flesh out the upper arms and neck, connect the torso to the hips and the thighs to the knees, and fill in the rest of the lower legs. Draw fingers and the thumbs. Add definition to the feet, using circular shapes to indicate the toes and heels.

4 At this point it might be helpful to either lightly erase some guidelines or work on clean paper laid over the existing sketch so things don't get too cluttered. Add details to the hair with zigzag lines to indicate strands and hair direction. Add pupils, irises, and highlights to his eyes. Flesh out the arms, defining around the wrists and elbows. Add his jeans and T-shirt, which will add some bulk to his form. Suggest clothing folds in his armpits, chest, waist, legs, and knees using a few zigzag or short lines. Draw his shoes.

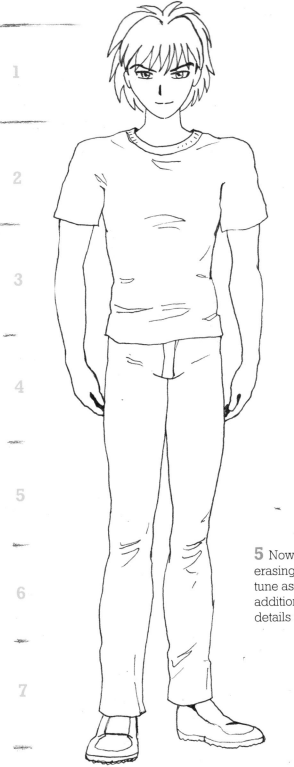

1

2

3

4

5

6

7

5 Now ink in the drawing, erasing the pencil lines, and fine-tune as needed, such as creating additional folds in clothing or details in the shoes.

DRAW A GENKI GIRL STEP-BY-STEP

This cheerful, energetic genki girl sports a wink and a smile and holds her hand toward the viewer in a "v" sign, which in manga and anime stands for "victory." It is a common gesture, especially with youthful characters. She is about five heads tall, and is drawn in a cartoony style.

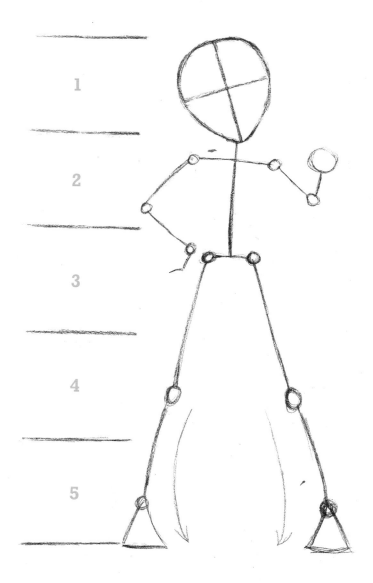

1 Draw the tilted, teardrop shaped head and divide into four equal parts. Measure down four head lengths below it. Frame out the body with the stick bones and circle joints technique. The hand reaching toward the viewer should be slightly bigger than normal to show that it is closer than the rest of the body. Note that the elbows don't quite reach line #2, while the hips are slightly below it and the waist exactly at it. Leave a small space between the other hand and the hip it will rest on for fleshing out later. Draw the lower legs with a slight curve (see arrows) to show that the girl is standing with her toes tucked inward.

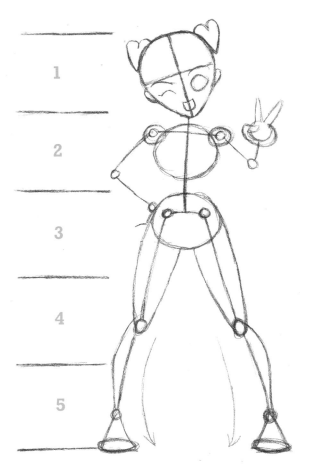

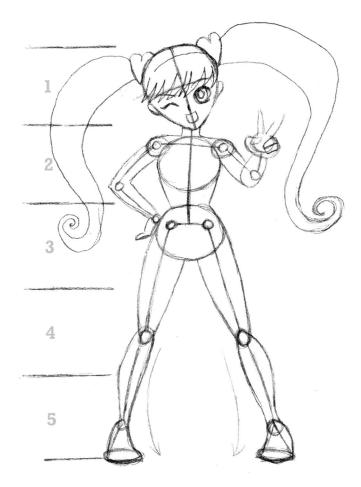

2 Draw the eyebrows at the horizontal centerline. Add the eyes, making one an open circle and the winking one a curved line. Add a small, open mouth. Add ears at the same level as the eyes, and heart-shaped barrettes where pigtails will go. Draw circles to flesh out the shoulders, chest, and hips, lining up the top of the hip circle with line #2. Flesh out the thighs and the outer curve of the lower legs. Draw fingers and ovals on the feet to indicate the toes.

3 Add huge pigtails and bangs, and a small mark for the nose. Flesh out the arms, and add the remaining fingers to the "v" hand and all the fingers to the other hand. Draw the waist. Add the inside of the lower legs, keeping the curve there much flatter than the outside curve of the lower legs. Finally, draw the feet, curving the lines (like the arrows) so that the toes look to be pointing slightly inward.

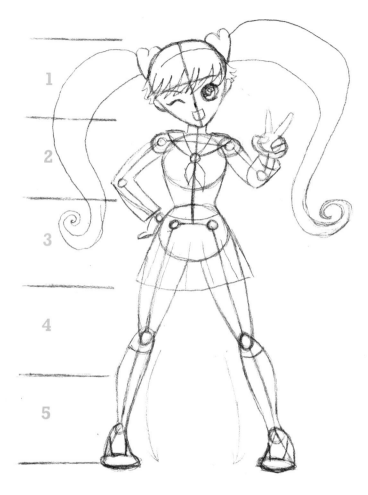

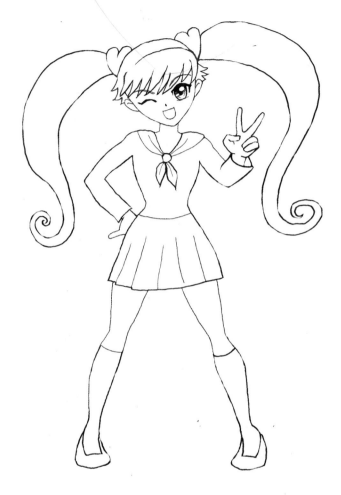

4 Add a few tufts of hair on either side of her head just above and behind her ears. Add highlights to her eyes. Draw the clothes (a school sailor uniform), including her shirt and sleeves, her skirt and long socks, and finally, her shoes.

5 Now finish the drawing by inking in the final lines. Once dry, erase the pencil lines.

DRAW A CHIBI HUMAN STEP-BY-STEP

This chibi human is characterized by its proportionately huge head and tiny body; in fact, this chibi's head is larger than its body.

2 Add arms and legs, including small circles and ovals for the hands and feet. Add irises and highlights to the eyes and a tongue in the mouth. Draw the ear and eyebrows.

1 Draw a circle for the head, tapering it slightly at the bottom. Since the face is angled up and at a three-quarter view, draw lines that divide the head into quarters but curve them up and around the face, as shown; the vertical centerline curves slightly to the right. Add the eyes and mouth. Chibis often lack a visible nose. Draw a bean-shaped body that is smaller than the head.

3 Add pupils to the eyes, and indicate tiny thumbs while leaving the hands almost mitten-like. Draw the curve of the inner ear. At this point the basic chibi is drawn, and you can add hair and clothes as you wish. I decided to draw a spiky-haired boy. I began with the outline of his hair as it grows away from his head, including the sweep of hair over his ears that will connect to his bangs.

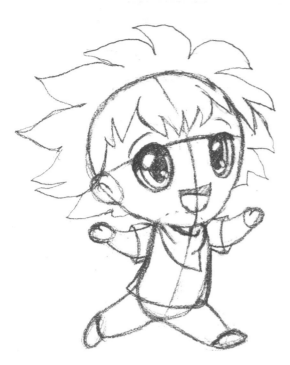

4 Complete the hair, drawing a pouf of bangs that connect to the sweep of hair from step 3. Shade in the pupils. I added shadow under the top eyelid for dramatic effect and added another highlight to the eyes. For the boy's outfit, I gave him a short-sleeved shirt, pants, and a bandanna.

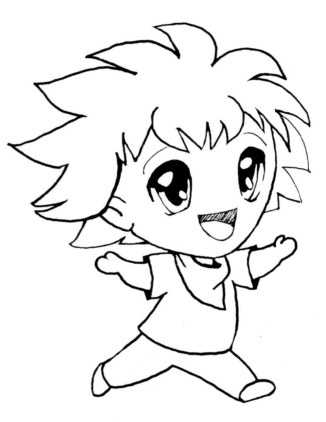

5 Now finish the drawing by inking in the final lines. Once dry, erase the pencil lines.

Here's where angle can affect how a viewer sees a character. The drawing on the left is from the perspective of a viewer looking down at a steep angle at the figure huddled on the floor below. His distress is evident in the closed-in, huddled posture while looking up as if asking for help or mercy from a more powerful person. From this angle, he looks small and vulnerable: much like a baby (right). Anything that reminds people of babies or someone similarly helpless can potentially trigger a sympathetic, protective response.

Gestures that capture childlike innocence and energy can also be appealing. The figure on the left kicks up his heels in a childlike manner, conveying a youthful restlessness and innocence. The girl on the right is happy and bouncy, even down to her hair. The arrows indicate the general upward thrust of the ink lines used to draw this figure. Note how many of the outlines of her body point up in the arrow's direction. These curved lines that arc upward add to the joyful, swirling energy of the drawing, especially when combined with her happy smile.

A very moe, sad little girl like this will bring out feelings of sympathy from many viewers. Note how she clutches her teddy bear (something that contributes to the childlike innocence of the girl) and draws her hands and arms in.

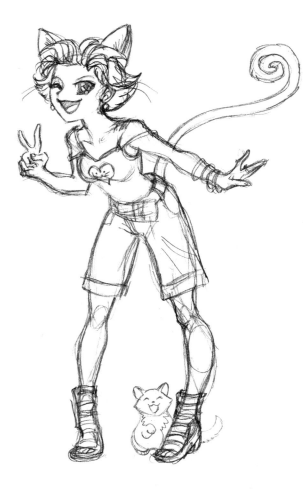

This catgirl has a confident, playful demeanor. Her uplifted tail accentuates that and she holds a hand in the "v for victory" sign that cheerful, perky manga characters often do. Winking at the viewers, she and her cute cat invite them in to share in the fun. This friendliness can add appeal.

To make characters look powerful, try drawing them from a lower angle, as if the viewer is small and is looking up at someone taller. This can have different effects, depending on the character and situation. If the character is a hero, it makes him appear more commanding and epic. Showing a dramatic and heroic side to your character brings appeal. However, if the character is a villain, it can seem intimidating. If you don't know whether the character is a hero, villain, or neither it can lead to feelings of apprehension and possible danger.

CLOTHING AND ACCESSORIES

Clothes are an important part of almost any character and can be used to make your character stand out. There is an infinite variety of clothing out there and the clothes a character wears can say a lot about their personality. Look around you. Use a mirror to draw the clothes you're wearing or sketch friends and family and the clothes they wear. Take note of folds and wrinkles and how cloth drapes over the body and bunches up near joints like the knees and elbows. Study fashion magazines.

This leaping figure is fairly dramatic as far as poses go but doesn't stand out and is a bit generic.

Add a coat, however, and suddenly he looks much more striking. The buckles, straps, and long, billowing coat make for a dramatic composition and many interesting things to draw. The outfit is distinctive enough to stand out from an ordinary coat and be memorable.

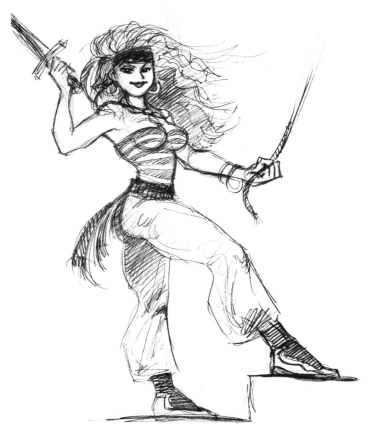

Some articles of clothing lend themselves to certain professions, livelihoods, and hobbies. This pirate wears a striped shirt that suggests a nautical theme. The sash wrapped around her waist adds to the pirate look and provides visual interest. Her headband is distinctive and also useful. The dark cloth separates her face from her hair, even in black and white, and that contrast helps make her face stand out.

This woman has a long braid and a scarf, both of which can provide interesting design elements for a character. Anything that falls from the body like a scarf, long hair, a cape, or a long coat can add life to your drawing and can be an extension of that character. A scarf can be drawn blowing in the wind for an interesting design or trailing behind someone running fast, showing motion.

DRAW OCEAN GIRL STEP-BY-STEP

In this example I wanted to create an appealing, cute character and decided to go with a typical shojo heroine. Ocean Girl is young, eager, and full of optimism. She might live near the ocean or perhaps she just loves vacationing there. She wears a traditional sailor suit school uniform but I added additional beach-themed elements, like shell and starfish designs. She crouches down on the ground and looks up at the viewer with a friendly smile. Her ocean-themed accessories and cute crab sidekick add a touch of whimsy, creating even more appeal.

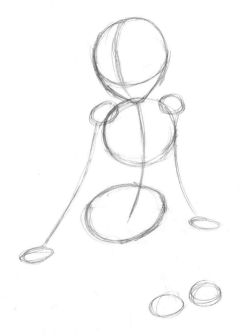

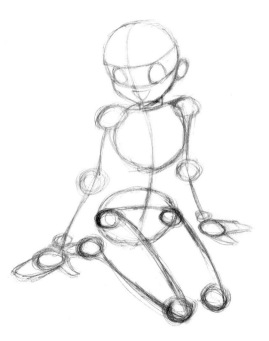

1 Block in Ocean Girl's basic body shapes using circles to indicate her head, chest, and hips as well as smaller circles for her shoulders and knees. Curved lines suggest the basic position of her spine and arms, and two curving perpendicular lines begin blocking in her face.

2 Continue blocking in basic shapes, adding another guideline to her face to indicate the top of the eyes. Start to add facial details. Block in the girl's elbows and hands, and better define her hip and leg positions.

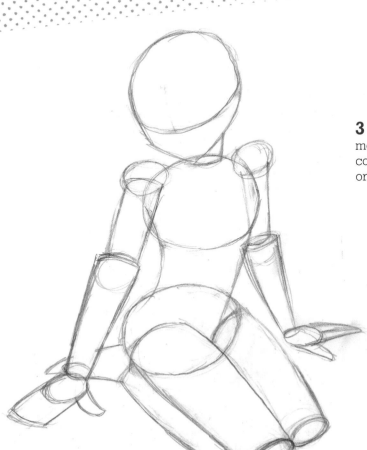

3 This drawing shows her body as basic geometric shapes, worked out with circles and cones as well as the occasional more square or rectangular shape.

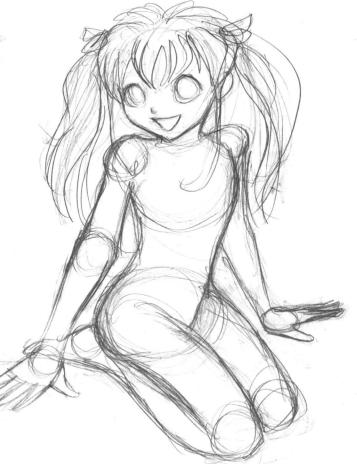

4 Go back over your initial drawing and lightly erase the previous outlines before going over them with more finished definitions of the body's shape. Also block in details of her hair and hair accessories, and her fingers.

5 Further define your girl with stronger pencil strokes and careful erasing. Add her sailor suit school uniform and oceanic elements and accessories. Note that the skirt's pleats radiate out from her hip area, indicating a three-dimensional form. Add highlights and large pupils to her eyes to give her a lively, innocent look. Draw her cute chibi crab friend.

6 Ink in her pupils and the shaded lines of her eyes. Ink the details of her hair and clothing, as well as the shell and starfish motifs of her accessories. Complete the details on the chibi crab. Once dry, erase any remaining pencil lines.

WINGS

Some characters are drawn with wings, which can be realistic or more stylized. Wings are normal for birds, of course, but on something like a human they can add an interesting and potentially dramatic element.

Here are two views of a basic bird's wing. On top is an inside, or front, view. On the bottom is the backside (or top) of the wing.

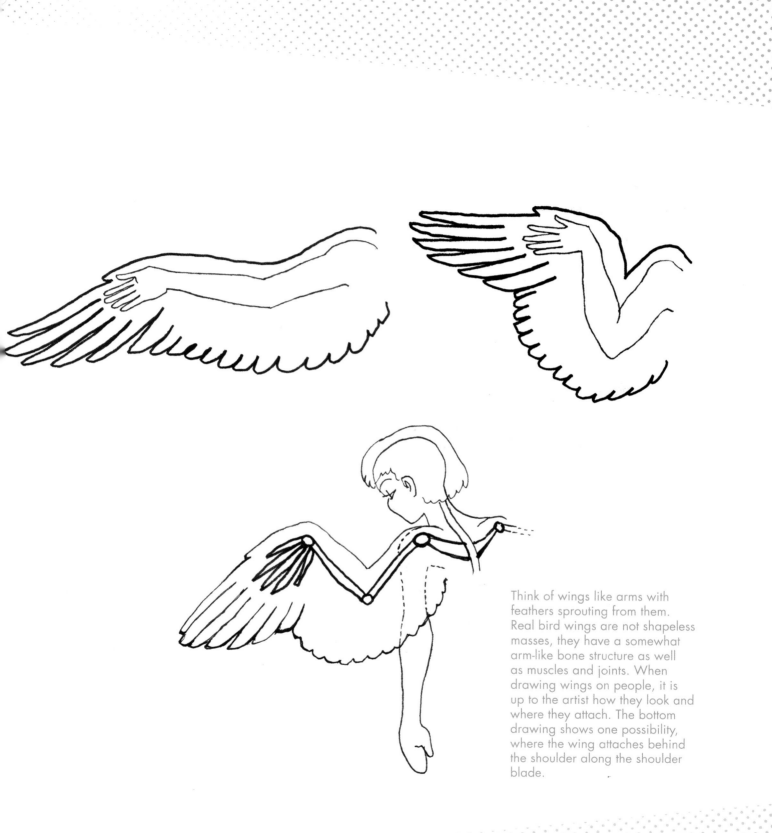

Think of wings like arms with feathers sprouting from them. Real bird wings are not shapeless masses, they have a somewhat arm-like bone structure as well as muscles and joints. When drawing wings on people, it is up to the artist how they look and where they attach. The bottom drawing shows one possibility, where the wing attaches behind the shoulder along the shoulder blade.

ANIMAL BODIES

Animal bodies are similar to human bodies as far as the basics go. Many of the more commonly drawn animals have the same structure: skull, two front legs (arms), two hind legs, feet, and a rib cage attached to a spine.

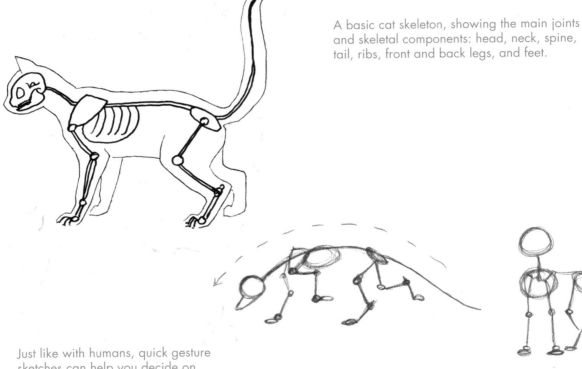

A basic cat skeleton, showing the main joints and skeletal components: head, neck, spine, tail, ribs, front and back legs, and feet.

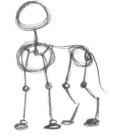

Just like with humans, quick gesture sketches can help you decide on the pose you want your character to assume. These gesture drawings can be as simple as you like, just keep them quick and don't worry too much about details yet.

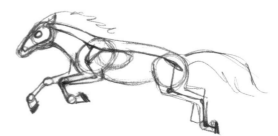

GENDER, AGE, AND CHIBIS

It is difficult to show all the possible comparisons between males and females and between the adults and young of animals as was done with humans earlier, because there are a huge variety of animals and showcasing them all is beyond the scope of this book. However, here are some general tips that can be helpful when drawing animals.

DOGS: MALE, FEMALE, PUPPY, CHIBI

While the differences between male and female dogs are not always obvious to a human observer, taking a trait one expects in humans and applying it to a cartoon dog character can be effective.

This male dog is drawn with a comparatively larger chest and smaller hips, something often found in human males. His head is also more massive and blocky. Note how thick the muzzle is compared to the female dog at right and the puppy dog on the following page.

Human females often have comparatively wider hips and narrower shoulders, so this female dog was drawn with comparatively large hips and a narrower chest. Her muzzle isn't as thick as that of the male dog, and her eyes are comparatively larger.

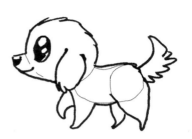

Most young animals have comparatively larger heads and eyes, and this puppy is no exception. His head, shoulders, and hips are all about the same size. You can use these proportions with most manga animals to convey youth or innocence.

Like chibi humans, the chibi dog has a comparatively huge head. Its body is about one head length long and vaguely bean-shaped with four little legs tapering from it.

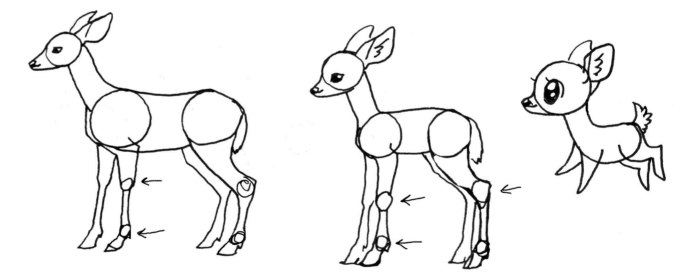

This drawing compares deer from adult (left) to baby (center) to chibi (right). The basic differences of head size in proportion to the body, the degree and amount of forehead slope, and the comparative size of the joints apply to many kinds of adult vs. baby animals.

In this comparison of an adult dog (left), a puppy (middle), and a chibi dog (right), note how the forehead of the adult dog blends a little more with the top of its muzzle while the forehead of the puppy has a more pronounced stop and steep slope upward from the muzzle, making its forehead appear larger and more pronounced. The chibi also has a large forehead. Note, too, the comparative size of the joints in the legs (arrows point to the "wrist" joints in the front legs and "ankles" of the hind legs). Young animals often appear gangly and clumsy. Their large, knobby leg joints contribute to that look. Note how the joints of the puppy's legs appear much larger in comparison to the rest of its body than the adult dog. The chibi is very simple and not depicted with joints at all, though arrows depict the main direction of the lines used to draw its legs.

DRAW A CUTE CAT STEP-BY-STEP

Everything about this cute cat is circular, from its head and body shape to its feet, eyes, and accessories. This simple, open shape gives the cat an open and friendly demeanor that can have broad appeal to many viewers. You can draw the cat in four steps or add aviator accessories and complete it in six steps.

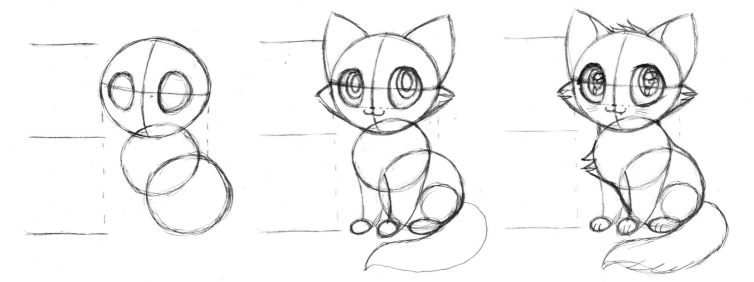

1 Draw a circle for the head and divide it into equal quarters. The face is slightly turned away, so draw those lines so that they curve to the left and just a little bit down. Mark guidelines at one and two head lengths below the head, as shown. Draw two body circles within this space, the top for the chest, the other for the hips. The body angles away just slightly, so the circles should overlap each other a bit as they go down and to the right. The dotted lines extend straight down from the head. Note how the two body circles are drawn to the right of the dotted lines.

2 Add the pupils and irises to the eyes, a nose (which should line up with the lower lids of the eyes), and a small mouth. Draw triangle shapes for the cheek ruffs on either side of the head. Sketch in ears from the cheeks upward if you aren't adding clothes. (You can skip this step if you're adding the helmet.) The front legs should taper from the chest and the hindquarters can be drawn as a smaller circle within the hip. Add ovals for the front and hind feet, and a curvy tail.

3 Add highlights to the eyes and further define the cheek fur ruffs. Further define the upper and lower eyelids. Add toes using simple, slightly curved lines and some fur tufts in the tail. Draw whiskers on either side of the mouth, and a small fang. Add fur tufts coming from the chest and connect the two circles of the body, adding more to the belly and back. Add details to the ears and a tuft of hair on top of the head (unless you'll add the helmet in step 4). If you like this cute cat as is, ink it in, let it dry, then erase the pencil or guidelines and you're done!

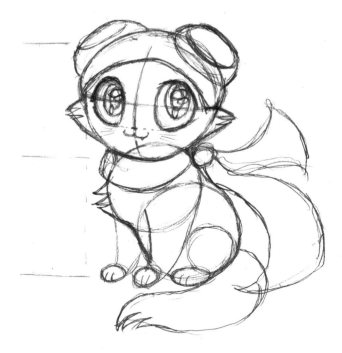

4 To continue drawing the pilot kitty, you can lightly erase the ears and add the aviator helmet, placing the eye cups where the ears were. Block in a scarf around the neck.

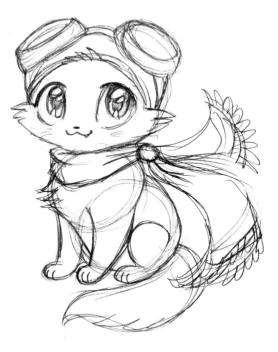

5 Erase some of the guidelines and add definition to the face and the body. Note the little tuft of hair sprouting from the forehead just under the hat.

6 Now finish the drawing by inking in the final lines. Once dry, erase the pencil lines.

5 SETTINGS, SCENES, AND SAMPLES

Once you have created a character and her wardrobe and accessories, there are some additional things to consider, such as what props she might be likely to carry around. The items she carries are as important in revealing her personality as her hair, clothes, and accessories. Where a character lives also reveals a lot, and it is worthwhile thinking about his environment and how it shapes him. Once that world is pretty well-defined, record it on a character sheet (page 156) to assist you as you draw in the future.

This character wears her environment in the form of leaves and flowers. These decorations and her animal friends suggest that she loves nature.

PROPS

The items your character carries can provide clues to their personality, hobby, or job. Be sure to research your props. Even for a fantasy world, conducting some real-life research can help your drawings look more convincing.

This young woman's tools suggest that she might be an engineer or mechanic. She can probably fix anything that breaks. The multiple pockets in her cargo pants also suggest storage space for yet more tools and provide a way for her to bring out new tools without having to constantly draw them each time.

Sometimes it is fun to take a concept (for instance the ancient practice of throwing a spear) and try to come up with a new or interesting way to have someone do it. Here, I tried to develop a "steampunk" spear thrower (top). (Steampunk is science fiction meets gothic. It is a genre that incorporates Victorian-era steam powered technology with fantasy or science fiction components.) I thought that the young engineer/mechanic might have this. First it can be helpful studying real-life weaponry, such as spears and rifles like this .308 (bottom). Then add gears and other elements and combine them in a way that looks functional.

This woman's nautical-striped shirt, billowy pants, large gold earrings, and the sword she carries help suggest that she is some kind of swashbuckling rogue or pirate. If you wanted to go with a truly stereotypical pirate look, you could give the character an eyepatch or peg leg.

Between the outfit and the racket in her hand, there is little question that this woman plays tennis.

DRAW SPACE WEASEL STEP-BY-STEP

Space Weasel is another one of my characters and was created with something zany, fun, and video game–inspired in mind. Space Weasel, Space Chicken, and Lyra have often found themselves together on misadventures. Space Weasel chases Space Chicken but never catches him. This could be because he has a short attention span and would rather play video games! Here he holds his space gun, which is probably more likely to shoot food marinades for chicken than actual lasers or anything. The extremely stylized gun, the helmet, and the "space rings" all help give him a futuristic, cartoony look.

The design of Space Weasel's weapon is very simple. The key is that it look futuristic, so I went with simple, rounded shapes that echo some of the shapes already found in the weasel and his helmet.

1 Sketch a slightly squashed oval, wider than it is tall. Draw an elongated oval for the body, widening it just a little toward the bottom. Divide the head into quarters, creating a three-quarter view by curving both the vertical and horizontal lines and by the off-center placement of the vertical line.

2 Erase the top part of the body oval that's inside the head oval. First work on the key parts of the visor—the lower part, which is formed by the horizontal curved line and the earpiece, which is a circular shape on the side of the head. Add the chin strap, the center stripe, and the lightning design to the helmet. Draw another bean shape about where the chest will be, and add the hind legs and feet. These are all fairly simple shapes.

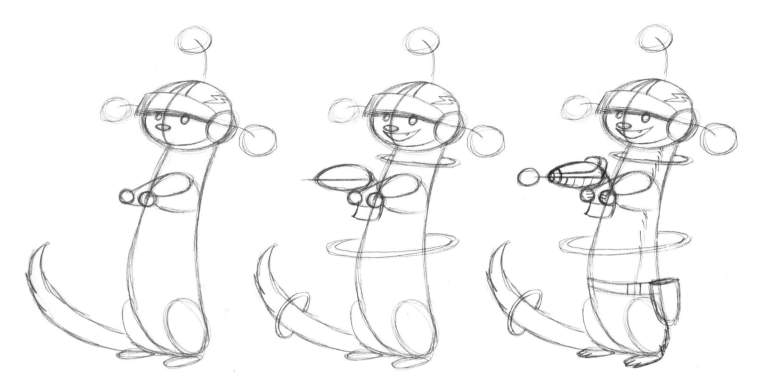

3 Add the bouncing balls attached to the top and sides of Space Weasel's helmet. Draw somewhat vertical ovals for his eyes and a horizontally placed oval for his nose. Add a tail. Then use the shape of the chest to help guide you while drawing the tops of his arms. They should flow smoothly from his chest out in front of him. Add curved lines underneath them for the bottoms of his arms, letting them taper and become narrower toward the paws. Add circles for the front paws, in which he'll be holding his space gun.

4 Add a mouth, including a little snaggletooth fang. Sketch the rings that somehow stay afloat around his neck, body, and tail. To draw the gun, first make an egg shape and an attached curved handle. Draw a straight horizontal line dividing the egg in half.

5 Lightly sketch in a fur line, dividing his lighter belly fur from his darker back fur. Finish the gun by curving that horizontal line up above the oval to add a rim along the sides that sweeps up into an arch above the rear of the gun. Add a ball barrel at the front tip and ridges around the tip and along the underside. On Space Weasel himself, draw toes on his paws and further define the division of his lighter belly fur from his darker back fur. Add his gun holster and belt.

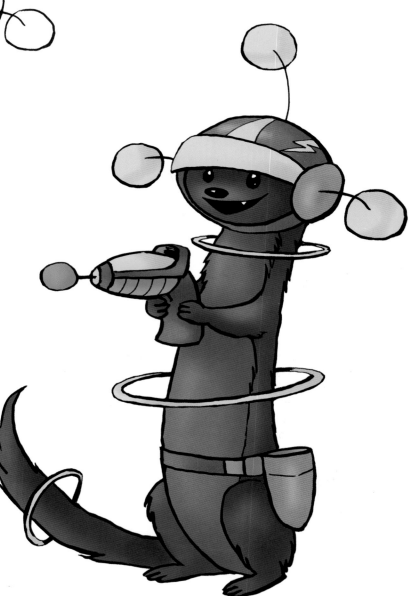

6 Now finish the drawing by inking in the final lines. Once dry, erase the pencil lines and voilà! Space Weasel, ready for trouble.

Space Weasel is bright and colorful.

CHARACTER DESIGN EXAMPLES

It can be helpful to see the process of how other artists approach character design. Reading about various difficulties that can be encountered can be useful when you run into similar issues. Here I've included several examples of character designs and how I got to each final version. Some were easy and some took a lot more time to finish.

SPIRAL CHARACTERS

I wrote and illustrated a comic book story I called *Spiral*, which was published by Radio Comix. It features a girl from our world who finds herself transported to a fantasy world by mistake, then turns into a gryphon. Here is a look at the development of some of its characters. Keep in mind these drawings are years old. Still, I believe they provide an interesting look at the development of a cast of characters.

This is my character Lydia in her gryphon form. I've tried to keep some hints of her human appearance, including long tufts of feathers on her head that look like bangs.

LYRA

Lyra came about while I was randomly doodling "magical girls" one day. It wasn't really a genre I typically spent a lot of focus on. Therefore, I hadn't drawn many magical girls. But this day I felt like drawing some and Lyra came to mind pretty quickly. The finished version of Lyra is on page 20.

This is my very first drawing of Lyra. Her tutu wasn't there in the beginning, but the puffy appearance of the skirt was already in place. Her belt and the gem on her forehead were bigger and her shirt had straps. The hair on top of her head became more rounded and less spiky over time.

This was another early design. I liked this girl, too, but she also had a more complicated design and Lyra was simpler. Ultimately, I went with the simpler, cleaner design. Lyra went on to appear in my comic *Spiral* as well as my book *Drawing Manga Animals, Chibis, and Other Adorable Creatures.*

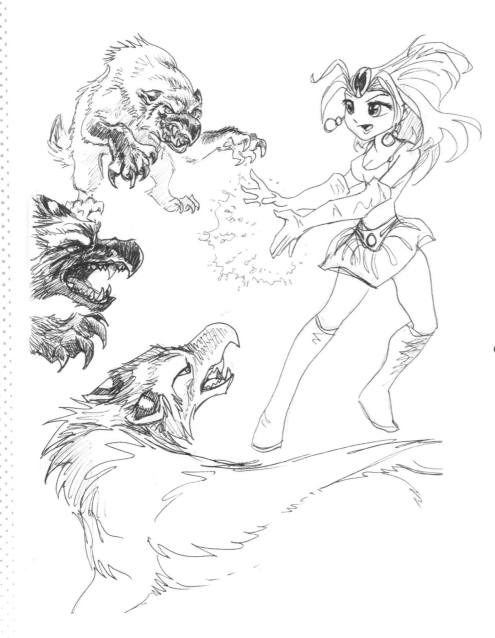

In this early Lyra drawing, she's depicted battling fantasy creatures I call karmacs. She still has the high-topped hair, large gem, puffy skirt, and blouse with straps from her earliest version. Her boots are not quite as high up her legs as they get in her final version.

Here's a chibi version of Lyra, wearing a different outfit. Some things remain the same: her hair, earrings, and the gem on her forehead. She wears a skirt, but it's not puffy. Her clothes are more layered and feature a different, heart-shaped design as opposed to the simple shapes she usually wears. Her shoes look more like ballerina shoes than they do in her final version.

LYDIA

Lydia is the heroine of my story. She's an introverted, rather quiet individual who has to gain confidence and learn how to adjust to an unfamiliar fantasy world where she is very much a fish out of water.

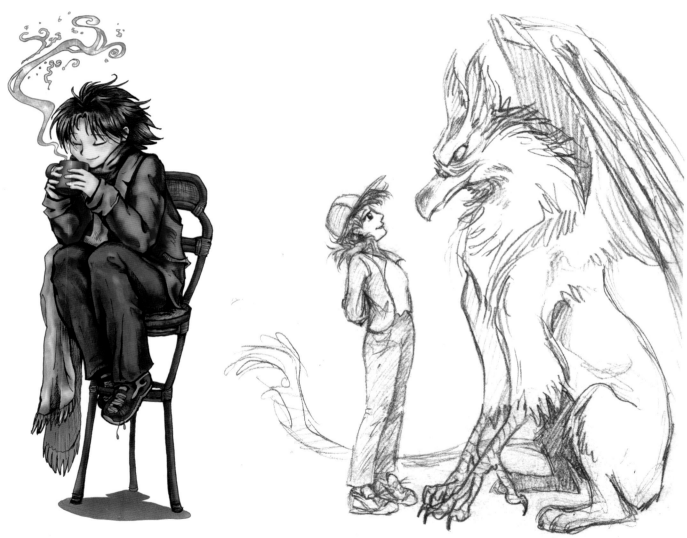

Lydia underwent many changes to get to this fully developed character, as you'll see in the pages that follow.

In the story, Lydia turns into a gryphon thanks to a magical piece of jewelry she stumbles across. This very early version of her shows her in a baseball cap and jeans.

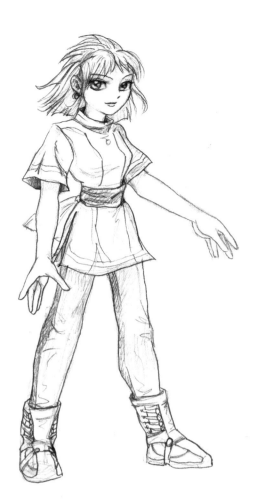

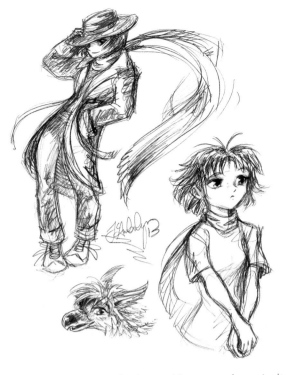

Something I hit upon fairly quickly was to have Lydia wear a long coat, a wide-brimmed hat, and a scarf. This was actually based on an outfit I had and liked at the time! One nice thing about basing an outfit on one you actually own is that you can stand in front of a mirror and see how the clothes fit on the body.

She quickly lost that tomboy outfit as I experimented with other ones, including this high-collared, poufy-sleeved one. I soon realized that I wanted her to begin the story very covered up under several layers of clothes. She would shed some of these clothes as she transformed over time and became more confident. Here's an example of a visual change informing the viewer that there's been a corresponding change in the character's psyche.

The scarf turned out to be useful in several ways. It provides a nice compositional element to any drawing of Lydia. It also can be used to vaguely suggest wings, which makes sense, given that she turns into a gryphon.

The coat, scarf, and sometimes the hat remain. Meanwhile, I decided to dress her in her short-sleeved shirt from earlier when she emerges from under her heavy coat.

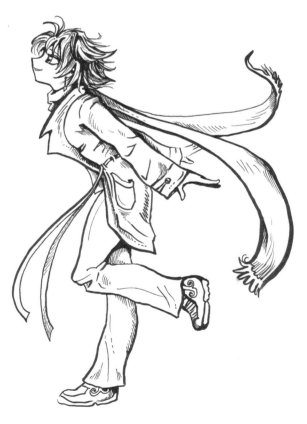

CAISIN

Caisin is a young military man. I wanted him to look athletic and have a military-style outfit. His uniform gave me fits, and it took a long time before I was satisfied with its appearance. Sometimes you just have to keep working at something until it clicks. It can also be useful to take breathers if something isn't working and come back later with fresh eyes.

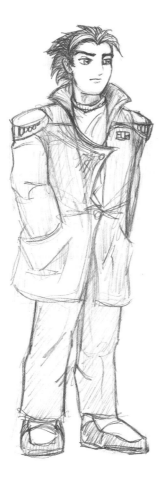

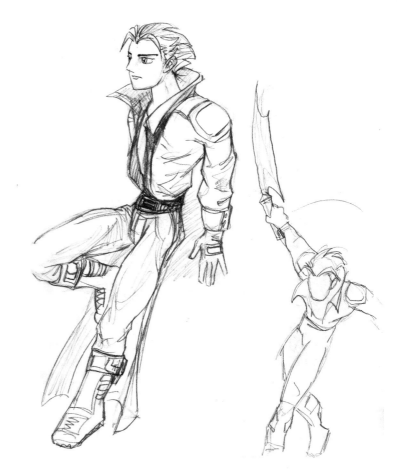

At first all I knew was Caisin was in the military and was a fighter. I thought he might have boots and a coat of some kind, but wasn't sure exactly what.

I settled on the top half of his coat fairly quickly, giving him some shoulder armor, large cuffs, and a large, high collar.

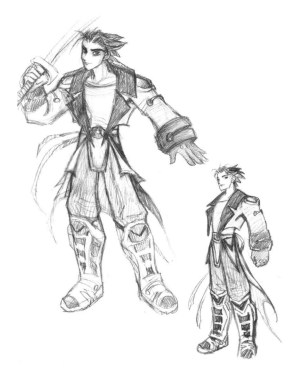

As time went on, I added more straps to the sleeves, increased the size of the cuffs, and flattened the collar though the size remained fairly large.

I had a lot of difficulty with the lower half of the coat, though. I tried a short coat and a long one but neither seemed right. I also wasn't sure exactly how to handle his pants and boots. Eventually I gained some inspiration from samurai armor. I tried solid and then a split padding coming from his waist that would provide some armor while also allowing freedom of movement. Plus, I thought it looked cool and was interesting to draw.

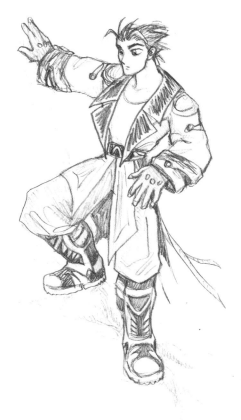

I also added long coat straps that could blow in the wind and provide an extra compositional element. Once I had figured this out, I was able to work out that I wanted knee-high boots. The boots themselves became one of the last things I finished designing as I worked on their patterns and style.

CAISIN: FINAL DESIGN

Here I drew Caisin as he looks today. First, I sketched in the basic forms of his figure, using circles, ovals, and other shapes to help block him in.

Then I went over the drawing, adding details and clothes, making sure to draw the outline of his big, bulky coat away from the outline of his arms. If he were wearing something skintight I'd keep to the original outline, but his coat is made of thick material so it needs bulk.

Finally I used a brush pen to ink the drawing in, adding fine details with a .3 pigment liner. Once that was done, I erased the pencil lines.

MYSTERIOUS YOUNG MAN

A mysterious young man developed for *Spiral*. He had not yet appeared in the story but I had worked on his character design and background.

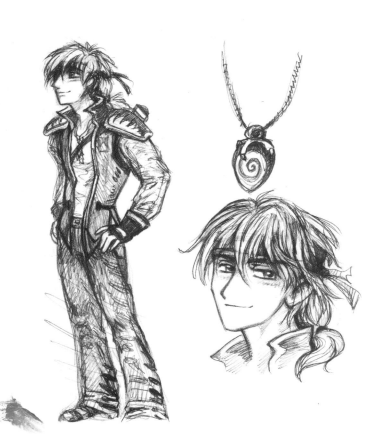

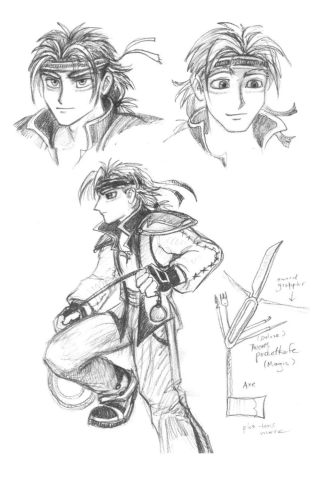

A recurring theme for the male characters in *Spiral* is shoulder armor. It's a theme that unifies characters of this particular fantasy world. Having the same visual themes occur several times on different characters creates a recognizable "look" for your world.

I wanted this character to have a different weapon than the others. I settled on a bolo, a primitive weapon that consists of two balls tied together with rope that is swung at prey or an enemy and snares them. He also got a knife.

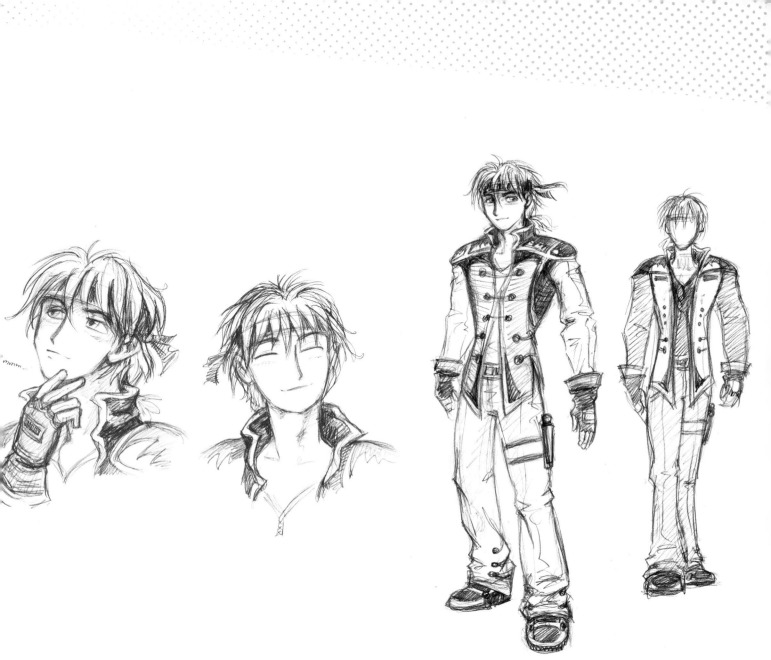

A more finalized version of our mysterious man. I might still change his look. That's the nice thing about character design, when you don't have a deadline. You can keep experimenting until you get it right.

This young man was developed for *Spiral*. He hasn't made a published appearance, but his design is worth sharing here. Like Caisin, he presented a challenge. I spent a lot of time working on his outfit and might still change something here or there. Where Caisin is more hot-blooded and formal, this character is much more easygoing, and I wanted an outfit that looks slightly like a bandit's.

INSECT PEOPLE

An important part of designing a character is developing something that is both familiar and different at the same time. This can often be achieved by taking inspiration from one source and applying it to another. In this case, I chose insects and applied their characteristics to some human-like fantasy people. There is an amazing and endless supply of all kinds of insects of various shapes, sizes, and colors, and using their designs for the basis of human-like characters and their clothing provides a world of possibilities. It's often helpful to begin character design by finding something you already like (such as insects) and developing it in a way that hasn't been done before.

BUTTERFLY WOMAN

For this butterfly lady, I wanted to incorporate butterfly wings into her design. There were numerous ways to do this.

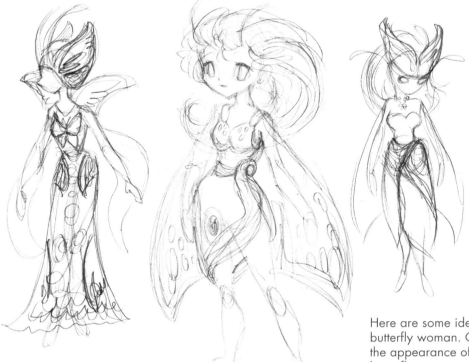

Here are some ideas I played with for the butterfly woman. Could I use a cloak to give the appearance of wings? Simply include butterfly wings into the design of her dress? Could I create a headdress that gives the appearance of wings?

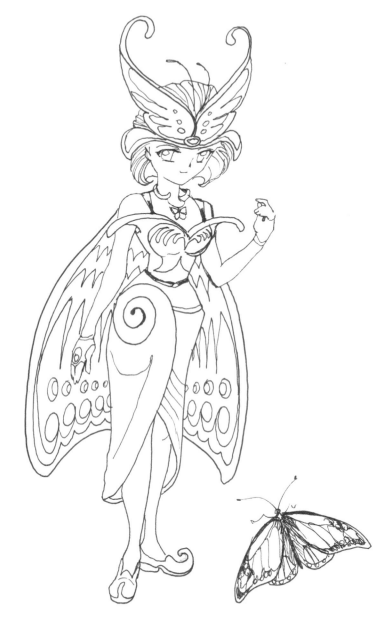

In my final design, I retained the ideas of using wings as part of her dress, and the winged headdress. Her dress is reminiscent of a caterpillar's cocoon.

Try to think how you can take ordinary objects and make them unusual. Here, the Butterfly Woman's small size was used to enable her to interact with objects like acorns and use them as drinking cups, and use leaves and feathers to pad where she sits.

I was thinking that these insect folk might be about insect sized. What might insect-sized people ride? Insects seem a likely answer, and I've always liked drawing big, fuzzy sphinx moths. So I decided their mounts could be large, horse-like moths. Now that I've researched scarab beetles for my beetle warrior and sphinx moths for her trusty steed, I can research real-life horses and riding tack (equipment) to help me envision the kind of gear this warrior might use to ride her moth. For instance, here is a basic bridle on a horse.

Here, a young woman rides a horse in western tack. Using real-life bridles and saddles as a guide, I can make a realistic-looking guess as to what a bridle and saddle on a moth might look like.

Lastly, I figured Beetle Girl might have a sword. I wanted her sword to be more fanciful, but first I looked at real-life swords, like this Japanese katana. Just like the horse tack, it is helpful to study real-life things before designing more fanciful ones.

Once I did all my research, I drew some thumbnail sketches (small, very simple and fast drawings) to try to get a basic idea of what I wanted to do. I wanted something for my warrior and her mount to fight against. I also like drawing geckos and thought a gecko could be attempting to eat some moth eggs, leading Beetle Girl and moth to defend them.

Once I had my basic composition laid out, I penciled in the final drawing. At first I roughed in basic blocky shapes, then added more details to them.

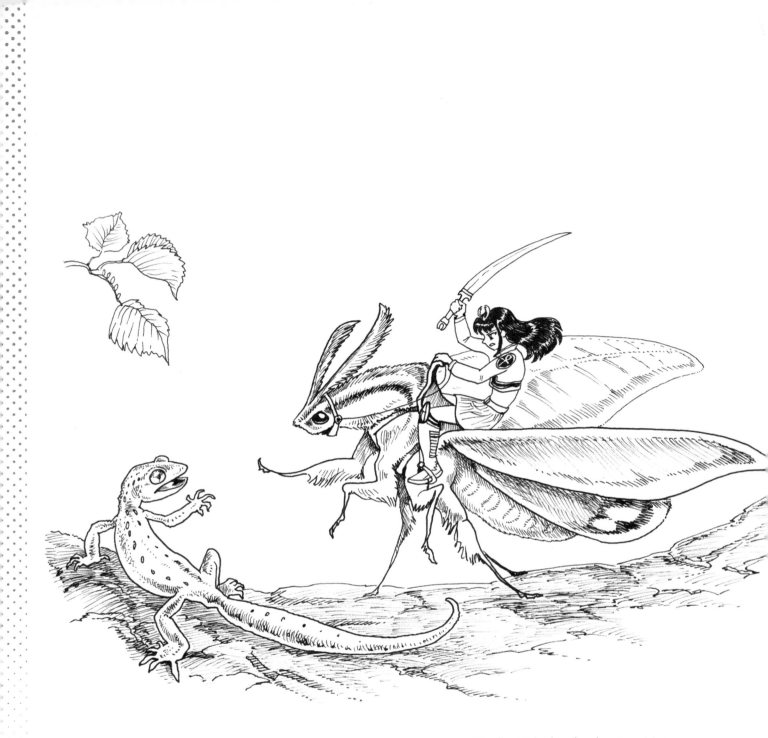

Finally, I inked in the drawing. Note the moth eggs on the tree branch above the gecko.

SILHOUETTES

One final thing to keep in mind when designing characters is their silhouette (the outline of the body). Many of the most recognizable characters in manga look unique enough that they can be identified by their silhouette alone. The outline is something one should consider when creating a new character. It sometimes helps to draw small thumbnail sketches focusing on the outline more than the details of the face or body. Look to exaggerate proportions when possible and appropriate. When you get to a silhouette that looks interesting and stands out to you, then you can begin to work on fleshing out the details. When developing a cast of characters, it can be useful to line up their silhouettes side-by-side and see how much you can make one differ from the other through proportion and silhouette alone.

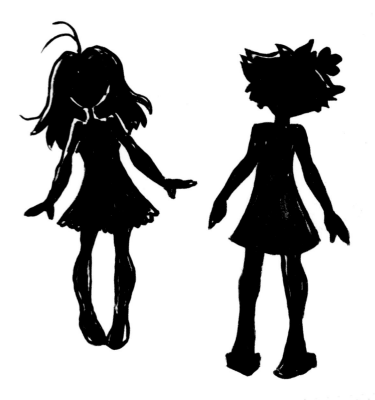

Here are the silhouettes of two young girls who are about the same age and build but are distinctive from each other due to the shape of their hair and clothes. The girl on the left has long, flowing hair, two strands that stick up from her head, a frilly dress, dainty shoes and turned-in toes. In contrast, the girl on the right has shorter hair that sticks upward, a simpler dress, bulky shoes, and a wider stance. Even without the details of their faces or clothing, you can easily distinguish one from the other. Silhouette is one simple way to differentiate characters that might otherwise look too similar to each other.

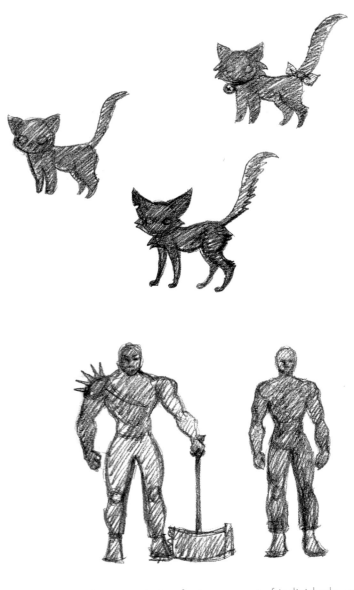

These cats are an example of how adding accessories, features, or changing proportions can affect the appearance of a silhouette. The left-hand cat has a fairly standard look without many distinguishing features. The one at top is the same basic body type but has a collar with a bell and a ribbon added on the tail. It's also been given a cheek ruff to add interest around its face. The bottom cat's proportions have been exaggerated quite a bit. The ears are much longer and there's a tear in the left one. The fur is shaggier around the tail, chest, and rump. The legs are longer, too, and the body is comparatively skinnier. These two cats stand out more than the blander individual at left.

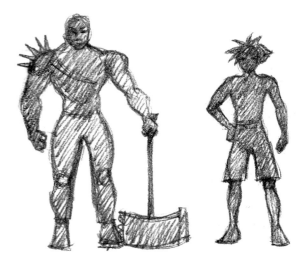

Most character design features a cast of individuals, and another way of making each one stand out is to be sure they look really different when they are standing together. For example, on the left is a large, muscular man. He holds a giant hammer and wears armor of some kind, including a spiky shoulder piece that really seems to stand out in silhouette. He looks distinctive. On the right is another fairly muscular man. Because his body shape and size are so similar to the man on the left, he doesn't stand out very well when placed next to him. The distinctiveness of both men is somewhat lost.

Here is the muscular man with a hammer again. This time, he's been placed next to a much smaller, skinnier man. The differences between the two are great enough that it really brings out the characteristics of both. The sheer size of the man on the left makes the man on the right look skinny, young, and possibly much quicker and more agile. The small, skinny man has spiky, upright hair that looks carefree and disheveled when contrasted against the leaner, more military haircut of the muscular man.

SCENES

Now that you have your character designed, you can think about the place they live. This is where perspective comes into play.

PERSPECTIVE DRAWING

Perspective is what allows an artist to render things as they actually look to a viewer in real life. It is a way of showing three-dimensions on a flat, two-dimensional surface so that everything in the drawing has depth. Here is a basic look at perspective drawing, which will help you when you draw the backgrounds for your characters. Using a ruler can help you achieve accuracy. There are many ways to approach perspective drawing; here are two of the most basic examples for you to practice.

Perspective drawing creates the illusion of depth. Objects appear smaller as they recede into the distance from a viewer. These techniques will help you create a world for your characters to move around in, whether it is realistic, fantasy based, and set in a city or out in the wild.

ONE-POINT PERSPECTIVE EXERCISE

In one-point perspective, objects seem to recede into the distance toward one central vanishing point on the horizon. The vanishing point is the point on the horizon where objects can't be seen anymore.

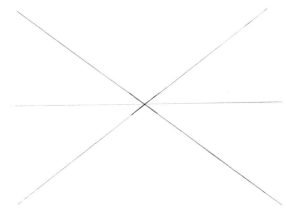

1 To achieve this simple one-point perspective, begin by drawing two perpendicular lines in the shape of an X. All angles should be 90 degrees.

2 Add a straight, horizontal line through the point where the lines from step 1 intersect. This is the horizon line.

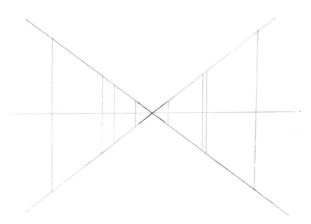

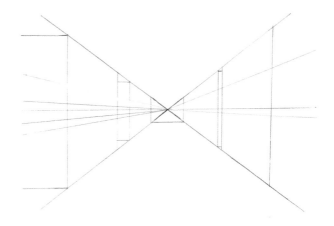

3 Now you can begin adding buildings and other structures or pieces of landscape. Use the lines receding toward the vanishing point to help guide you. Begin by adding a few vertical lines to indicate different buildings. This is a fairly modern setting, typical of a school-life manga story.

4 Add more X-shaped lines receding into the vanishing point to help indicate the tops and bottoms of doors and windows of various sizes, heights, and shapes. Add a few horizontal lines to show where the buildings begin and end.

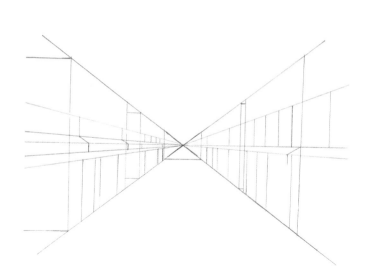

5 At this point, use vertical lines to start defining more of the doors, windows, signs, and over-hangs. There will be an overhang on the buildings at the near right and the near left, so start placing lines for them. (The slanted line for the bottom of the overhang will be drawn in the next step.) Don't worry too much about making every building match up exactly. Just like many real-life streets, each building is different.

6 Keep adding details, defining the tops and bottoms of windows, doors, and overhangs with more lines that recede into the distance until they disappear into the center vanishing point. This included the bottom of the overhang on the front right building. In addition, I added sidewalks and a dividing line in the street. Finally, I added details at the center vanishing point, including a cross street with more buildings and some trees.

7 To finish the drawing, add a few more details, including two figures (kids in simple school uniforms) window shopping as well as some of the text on the signs on the over-hangs. When you are satisfied, ink it all in, still using a ruler to help keep the lines straight. When the ink dries, erase the pencil lines.

TWO-POINT PERSPECTIVE EXERCISE

Two-point perspective is a little more complex than the one-point perspective because it there are two vanishing points instead of one.

1 Here's a basic rundown: first, draw a horizontal horizon line, and then draw a vertical line that will become the point or area you want to appear closest to the viewer. Then decide on two vanishing points on either side of that vertical line. These do not have to be exactly even on either side of the vertical line. I indicated these as dark circles on the horizon line.

2 Mark the vertical line above and below the horizon line, at a place that indicates the top and bottom of the shape you're rendering in step 3. Connect the two vanishing points to these points on the vertical line, as shown.

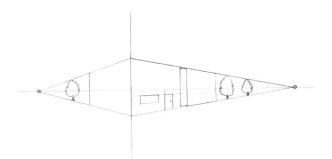

3 Begin blocking off individual shapes using vertical lines to distinguish one box shape from another.

4 Continue adding details. In this case, a door and window, and space between the two buildings. However, perspective drawing doesn't have to be man-made shapes only. It can include natural shapes. Add some similar size trees and use the perspective guides to determine how tall each tree should be.

INTERIOR SCENE EXERCISE

Here is a fairly simple interior drawn with one-point perspective. I wanted to show an artist creating something in her studio.

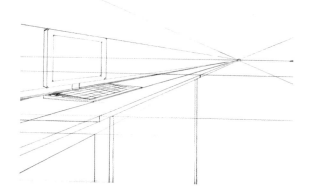

1 Where is a common place for many artists to work these days? At home on their computer. So this is an interior shot featuring someone working on their computer. The first step is to make the X for the vanishing point and draw the horizon line. After that, you can block in the desk and computer.

2 Add the artist (who's using a tablet connected to her computer) and her chair, desk, computer, and mouse. What does she need beyond these basics? Think about what motivates your character. Artists generally like to have books and magazines for reference and inspiration, so include some on the little table in the left foreground, along with loose paper and drawing pads. Cups full of pencils and pens suggest more "tools of the trade."

To suggest an inner world and a well-rounded character, place some "geeky" things around her desk: various toys and action figures, reflecting the artist's hobbies and interests. Finally, add her trusty dog watching her work.

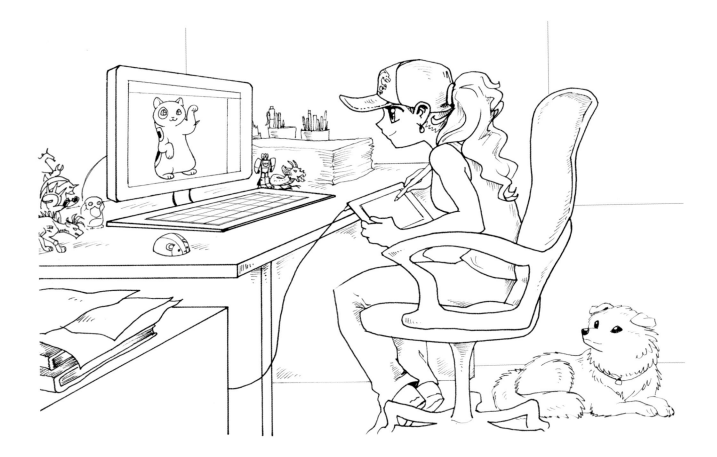

3 Once all the details are penciled in, ink the drawing. When it dries, scan it. After I scanned the drawing I added a few things on the computer that I could have added in pencil before inking and scanning. To break up the large blank space on the wall behind the artist, add a poster or window to the far right background. A vertical line behind the desk indicates the corner of the room and a horizontal line (at her ankle level) suggests where the far wall meets the floor. The far end of the base of the desk is hidden behind the artist's chair in step 2. Stretch the desk out just a tiny bit at the far end to make it visible behind the bottom of her chair. Now it is clear where the desk ends and the floor begins.

SEASIDE

Here I wanted to create a more natural environment, so I chose a seaside setting. I envisioned a young fisherman who lives by the sea, traveling from island to island with only his boat and his equipment.

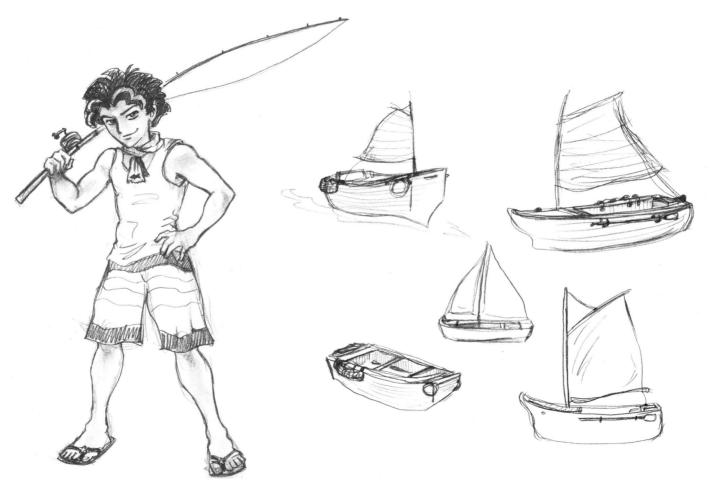

The young man is fairly muscular, because he has to live by his strength as well as knowledge of the sea. He'd have a fishing pole in addition to fishing nets he keeps on his boat.

His fishing boat might be fairly small, but he doesn't need a large one, since he's got a crew of one. I see this as some kind of fantasy or adventure story, so I don't want anything too modern, like a motor on the boat. I figure he'd want some sort of simple sail on it for speed.

It's time to come up with the setting and what the fisherman will do in it, so I ask myself, "If I were this character how would I use this beach?" It's tropical, hence the palm trees. After a long morning's work, he ties his boat to a tree and climbs into a hammock for a midafternoon nap. Maybe he's harvested a few coconuts for a snack later. He might have a few bags of gear or personal items tied high up in the trees where critters can't easily reach them.

This little crab belongs on a beach; maybe he's a mascot or friend of the fisherman. Maybe it is his friend, but since it's a crab it can't help but occasionally pinch him. (Getting randomly pinched every now and then is something that could be used for a humorous effect.)

It looks like there's a pirate ship out on the horizon. The fisherman has noticed it and seems concerned, looking as if it roused him out of his nap and brought him to full alert, indicating that something might be wrong. This creates instant tension and leads the viewer to wonder what happens next.

While a thorough look at composition and other similar art concepts are outside of the scope of this book, I'll point out a few basics here. When working on the composition of a drawing, keep in mind the "rule of thirds." Putting a character dead center in your drawing is usually rather boring. There are times it works but in general most images look better with the main subject a bit off-center. Divide an image into thirds horizontally and vertically. The intersections (as shown by circles here) are often good places for the main focus of your drawing, in this case the fisherman's head and shoulders. Note how the pirate ship is located near another intersection.

This drawing also uses foreground elements (the two palm trees in foreground) to help frame the background and provide depth to the scene. Take a look at the dotted arrows. They indicate ways that parts of the composition are being used to direct the viewer's eye through the picture. For instance, note how one of the palm tree fronds "points" directly to the pirate ship. Also note how even the wings of the seagulls, who appear only as small, basic "v shape" silhouettes, help point the viewer's eyes from one section of palm tree fronds to the other bunch.

CHARACTER SHEETS

Once you have a character pretty well fleshed out and looking the way you want them to, you can create a character sheet to show their final design. Character sheets usually contain drawings showing how a character looks from various angles, such as a front, side, and back view. They can be color or black and white, depending on the artist's or the production's needs. They can be fairly simple, just showing the turnaround of front to back. Or they can be a little more detailed, also showing some close-up views of the character's head demonstrating various typical expressions as well as showcasing some of the props the character might be likely to hold. Once you have some character sheets made, congratulations. You now have successfully completed the journey from idea to finished creation!

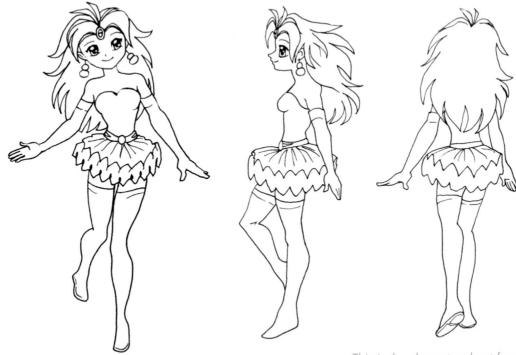

This is the character sheet for my character Lyra. It features a turn-around, showing her from a front, side, and back view.

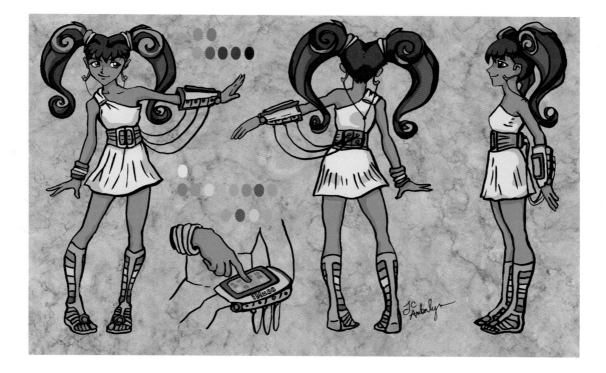

This is a character sheet for a "Modern Muse" concept I had. I wanted a character reminiscent of the ancient Muses: Greek goddesses who inspired the arts, science, and literature. But, I wanted a modern update. What would a modern Muse look like and how would she inspire people creatively today? To keep her recognizable as a Muse, I picked up the appearance of a Greek tunic but added some modern-day accessories, like her belt and a modern tablet/computer-like device on her arm; now she can access programs, play music, and contact people directly all over the world. Her classic-looking sandals contain a rainbow of colors, adding to a young and whimsical appearance. Note the small, same-sized ovals of colors. This is the color palette and each oval represents a color used on the character. This makes it easier to sample and select colors when coloring in the character later.

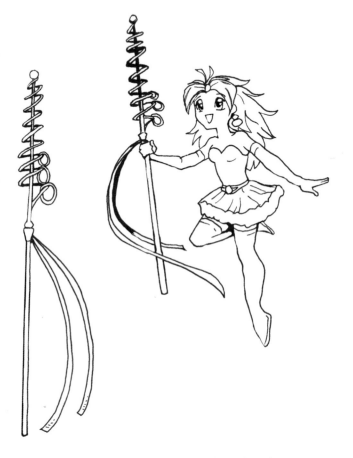

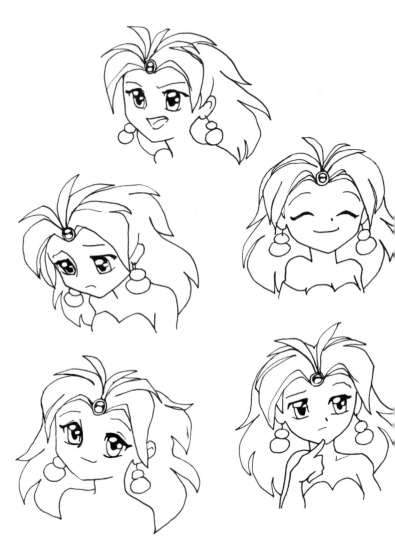

Here's a character sheet that shows the staff Lyra sometimes carries, and its size in relation to her. I also drew various head shots showing some of her expressions.

CONCLUSION

Now we come to the end of the book, but not the end of your journey as an artist, writer, or owner of this wonderful thing called the imagination. I hope you will continue to learn, to practice, and to grow your skills—whether it is in art or any other field of communicating ideas to others.

You have worthwhile ideas. You have your own unique stories to tell. Find your passion and share it. Your own characters and stories may grow and change over time, just as you do, so keep exploring both the outside and your inner world. Both are incredibly rich and rewarding places to spend your time. Art can help you organize thoughts and experiences into something simple and yet meaningful that you can then share with others—maybe even the world.

INDEX